A Special Gift

THE KUTCHIN BEADWORK TRADITION

KATE C. DUNCAN WITH EUNICE CARNEY

UNIVERSITY OF ALASKA PRESS
FAIRBANKS, ALASKA

Library of Congress Cataloging-in-Publication Data

Duncan, Kate C.
 A special gift : the Kutchin beadwork tradition / Kate C. Duncan
with Eunice Carney.
 p. cm.
 Originally published: Seattle : University of Washington Press,
c. 1988.
 Includes bibliographical references and index.
 ISBN 0-912006-88-9
 1. Kutchin beadwork. 2. Beadwork--Alaska. 3. Beadwork--Yukon
Territory. 4. Kutchin art. I. Carney, Eunice, 1909- .
II. Title.
E99.K84D86 1997
746.5'089'972--dc21 97-41710
 CIP

International Standard Book Number: 0-912006-88-9
Library of Congress Catalog Number: 97-41710

Printed in Canada by University of Toronto Press, Inc.

This publication was printed on acid-free paper that meets the minimum requirements for the American National
Standard for Information Sciences—Permanence of Paper for Printed Library materials ANSIZ39.48-1984.

Publication coordination by Pamela Odom, University of Alaska Press.
Cover design by Dan Kaduce and Dixon Jones, AMS Graphics, Rasmuson Library, UAF.
Index by Paul Kish, Kish Indexing Services.

Cover: Beadwork pattern drawn by Eunice Carney. Baby belt, made by Mary
Johnson and Julia Loola (Kutchin Athabaskan), 1920s, consists of beads,
velvet, moosehide, cloth, and yarn. It is part of a collection of the
Newark Museum, 84.520. Purchase 1984, Thomas L. Raymond Bequest Fund
and The Members' Fund. Photograph by Sarah Wells.

To Eunice, and all Kutchin beadworkers, past, present, and future

Table of Contents

Plates

Figures

Publisher's Note

When *A Special Gift* was originally published in 1988 the spelling "Kutchin" was normally used. This spelling remains in the title and the main text, as the book has not been revised for the second edition. Today, however, the Native-language spelling "Gwich'in" appears more frequently, and thus is used in the new introduction.

Likewise, over time four different spellings have been used for the name "Athapaskan": it may also be spelled with a *b* and *k* (Athabaskan), or a *p* and *c*, or a *b* and *c*. The Alaska Native Language Center of the University of Alaska Fairbanks uses the *b* and *k* combination, as it most accurately reflects the English pronunciation of the Cree Indian word from which the name originates. The spelling used in the original edition of this book is "Athapaskan"—the version used by the Smithsonian Institution in Washington, D.C., and most of academe. This spelling is retained throughout the second edition, unless part of a title. See Krauss (1987) and Osgood (1975) for more about how the name Athapaskan came to be used and why it is spelled four different ways.

Foreword

I was glad to meet with Kate Duncan and Eunice Carney when they came to Fort Yukon and talked about the older types of beadwork and how they came about.* I had the pleasure of listening to Eunice Carney tell how women used to get designs from dress materials and oilcloth table cloths.

Eunice Carney and my mom Clara Moses Frost went to school together in Carcross, Yukon Territories. That's how she became a good and very close friend of our family. After they finished school the girls all came home, got married, and some came to Fort Yukon and worked at the mission. I remember as a little girl at Christmas time at Old Crow we used to go to the dances and Eunice's mother used to wear a long dress down to the ankle with about a twelve-inch pleated ruffle at the bottom of the dress trimmed with ribbons and old fashioned braid. In the old days women had long hair, waist-length, parted down the middle and braided in two braids against the head then criss crossed with big bows of ribbon on each side. They wore pointed moccasins mostly, called sharp-toed moccasins, trimmed in beads or quills. I used to think when they danced it was a beautiful thing to see, like they were floating on a cloud.

Around 1927 when Eunicewas in Fort Yukon, she met and married Bill Carney. They had a place called the Show House and showed movies, mostly Westerns, and made ice cream and their own root beer. Whenever there was a dance they could have it there. In the 40s when I first came here everyone gathered in town after spending most of the year on their traplines. Every night the Show House would be full of people. Eunice always had time for others and was always telling stories and jokes. She used to do perms, too, and she also had a little store in the back. She was really a hard working woman.

Many years ago Indians made all their own clothing, with skins and fringes. Later, when the Europeans came with beads, then they started making floral designs on clothing, wall hangings, gun cases, and just about everything else. The women always had nice things for their husbands, and Chiefs had The Best. In the old days everyone stayed out on their traplines. All winter the women stayed home, tanned skins, and made them into clothing.

When I lived with Rachel, Eunice's auntie, she told me about hard times, even starvation. She taught me to tan skins and make babiche and braided ropes, all out of skin. Then we would gather some red ochre rock that they made dye with, to color along the outside seams on things made of white tanned caribou skin with the hair on the inside—things like one-piece pants with the feet part attached. The pants were trimmed with a few trade beads on a long leather thong. That kind of

* Doris Ward, a long time friend of Eunice Carney, was raised in the old way by Eunice's aunt, Rachel Cadzow, the wife of the trader at New Rampart. As a child Doris moved to Old Crow when the village relocated there, and later to Fort Yukon. A dedicated beadworker herself, Doris has watched the changes in Kutchin beadwork over many decades.

clothing was warmer than any store-bought ski pants you buy today. I know. I once wore those, too. There were no stores and we lived out from town and had to do with what we had.

In *A Special Gift* there are a lot of pictures of traditional beadwork. When we were young we didn't really have much interest in those things, because we lived seeing it all the time, and we had no tourists in Old Crow to buy beadwork. Later, when tourists started coming around, we had to explain about history and tradition and why and how people kept it up. I tell them I love to make beaded things. I just laugh and say, "You know, you can do the same if you work at it."

Years ago whole families lived off the land and out in the country almost all year round; that's where the women had time to make beadwork. People had to sew in order to put food on the table. Now we all live city life, and lots of younger people think they don't have to sew. It's hard for people to make a lot of things with skin now. We used to buy moose skin for $100. Now it's $500, $600, or $700. So, they're into other things—bracelets, hair pieces, sun catchers, scissors cases, coasters—things that don't require a lot of skin. Even beads cost a lot. So, these high prices keep some people from sewing. Some of the younger people do sew and they're doing good, but most of them can't make a pair of slippers or mittens or boots without someone else's help. They can make earrings, hair ties, little things. But you have to keep it up and you get better at it. Nowadays, a lot of women have newer designs and brighter colors.

Every time I sew beads it's tiring because it is slow work. But, every flower you make, you are happy it's done. Each time you finish something you are so happy, as if it was the first piece you completed. I like it as an art, but you have to sell them, too, in order to purchase material to start all over again and keep going. I see lots of work today that I think is beautiful, different styles.

Beadwork is taught in the schools, too, and the kids are really picking it up. Even the boys are sewing. When I taught beadwork classes, the girls liked floral patterns in more modern designs, while the boys made things like eagles and arrowheads. Most of the boys made things for their mothers and the designs they chose just came out of their heads. I was so proud of them. So, you see, the art of beadwork is not dying. It's a going thing.

—*Doris Ward*
1997

Introduction ✳ *1997 Edition*

Nearly fifteen years have passed since Eunice Carney and I traveled to subarctic communities to discuss photographs of early beadwork from the region. It was a trip rich in sharing and learning, as people graciously welcomed us and searched their memories. We were particularly interested in what was remembered about the beaded objects found in turn-of-the-century museum collections, about their making, their use, the designs beaded on them, and the factors that explain the changes in them. We also sought to compare them with contemporary beadworking and aesthetics, to gauge continuities and change over a century or so. We collaborated, using an open-ended interview technique, asking some directed questions, but mostly waiting for responses elicited by the photos themselves, then following up with further questioning.

Interviewing based in the examination of photographs, a technique recently called photoelicitation, is not new, but it is surprising how little it has been employed since the seminal ethnoaesthetic work of Lila O'Neal and Ruth Bunzel, early in the century.[1] When taking people to objects or objects to people is not possible, working with photographs of the objects is the next best thing. In the study of material culture, the use of photographs allows focused discussion on specifics of form, technique, and style that are difficult to talk about without concrete examples. Even more important, photographs stimulate memory in a manner that words cannot, and are especially useful when the subject being discussed dates to decades long past. The segments in this book on dog blankets and the "tin hat," both long out of use at the time we interviewed, are examples in point.

Our research trip, funded by the Urgent Ethnology Fund of the National Museum of Canada (now the Canadian Museum of Civilization), led to a fieldwork report which presented what we had learned in consolidation with what museum collections and the written historic record indicated. With minor changes, that report became the book *A Special Gift*, a descriptive narrative, with no critical framework intended. Our purpose for the book was to celebrate Gwich'in beadwork, its creators, and the richness and tenacity of the tradition, by making its history available in written form for Athapaskan and non-Athapaskan readers alike.* We were gratified to find that this, our special gift, has been valued.

1. The term was first introduced in the session "Photograph Elicitation for the Purpose of Object Documentation" at the American Anthropological Association 88th annual meeting in Washington, D.C., in 1989. It is significant, and worth further examination, that both the early ethnoaesthetic studies of Native American art and the sustained use of photographs in interviewing toward that end were the work of women. Ruth Bunzel, author of *The Pueblo Potter* (1929), and Lila O'Neale, author of *Yurok-Karok Basket Weavers* (1932), were both students of Franz Boas at Columbia University.

* See Publisher's Note, page xi, for an explanation of the spelling "Gwich'in" in place of "Kutchin" and for the spelling variations of "Athapaskan."

I am very grateful to the University of Alaska Press for assuming the rights to *A Special Gift* and undertaking this second edition, and especially appreciate their decision to increase the number of color plates. Eunice had hoped for a reissue and would have been thrilled as well that it has come to pass. In choosing the new plates we have tried to use examples that have not been published before. Very special thanks to Pam Odom who has supported and shepherded this second edition from start to finish.

Because the following remarks are not based on structured interviewing as was the 1982 work, individuals' names are not included, but I thank all who so generously shared observations in response to my recent informal questioning about how Gwich'in beadwork has changed since 1982.

CONTINUITIES AND CHANGES IN GWICH'IN BEADWORK

The contents of museum collections make it clear that beadwork has served Gwich'in women in multiple ways for over a century—as a focus for personal creativity, a symbol of ethnicity, a culturally sanctioned and celebrated vehicle for supporting essential human connections, and an economic boon in context of the realities of the pressures of acculturation. The quilled outfit acquired by Captain Henry Dawson in 1882 (Plates 9 and 10 of this second edition) reflects each of these categories. Exemplifying an old style of clothing, which by the 1880s was still in use among only a few western Gwich'in, it was most likely made for sale, and was possibly commissioned. Its cut and style of quillwork identify it as Gwich'in. The care and skill of its construction and ornament speak of a seamstress long experienced in producing the traditional clothing of her people. As was often common, other family members may have assisted in its completion as well. These essential

cultural connections are layered with another—the interface and accommodation between Native and non-Native, the maker sharing her pride and skill with an unknown European and participating in an economic system that has been thrust upon her. Like this quilled outfit, all of the beaded items in this book reflect in cultural terms the changing historical circumstances of their makers. Today, at the end of the twentieth century, Gwich'in beadwork continues still as an important personal, cultural, and economic marker.

As in the past, Gwich'in women's lives today are complicated, and often only sporadic beading is possible. Some women bead regularly to produce items for sale and for family and community use, others occasionally, as "bread-and-butter" money is needed. Many women concentrate on smaller pieces that can be completed in a short length of time, priced moderately, and sold more readily. Beading for family needs tends to focus on special occasions such as dances, the World Eskimo Indian Olympics and the Athabaskan Fiddlers' Festival, where elegant moccasins or dance boots are admired and highly prized.

Gwich'in florally beaded items in Fairbanks gift shops today tend to be the same as in 1982—solidly beaded hair barrettes, eye glass cases, check book covers, scissor cases, pendants, and tiny purses, along with beaded panels for applique on commercial hide gloves, and moccasin vamps ready to be sewn onto soles. The motifs and color choices on such items are remarkably similar, also. Some store owners have found that blue and pinks sell the best to visitors, so encourage that these colors dominate. Bazaars and the World Eskimo Indian Olympics are now also important selling venues.

In 1982 some women at Fort McPherson were using designs in W. Ben Hunt's and J. F. Burshears' *American Indian Beadwork* as inspiration for the patterning of bead-loomed baby belts, and others we interviewed kept a few

commercial patterns from the Celia Totus Company.[2] Today a Native-owned Fairbanks shop sells stamped moccasin vamp patterns, ready to be tacked to felt and beaded through, and barrette kits which include pattern, felt, beads, and instructions. White felt remains the common base for beading small objects and baby belts. Because hide is so expensive and well-tanned hides are difficult to acquire, moccasin prices continue to increase and women rarely make items such as jackets or dresses of hide.

Today, there are new additions to the Gwich'in repertoire. The burgeoning continent-wide interest in beads of the last two decades has expanded the range of available bead shapes, surface finishes, and colors within a given hue. New types of matte-finished, color-lined matte, and transparent beads (including ones with square holes) and various types of frost finishes have joined the opaque, translucent, transparent, and color-cored beads long available. These newer types are most often used on the "suncatchers" and earrings that are now especially popular among younger beadworkers.

The suncatcher is related to the "dream catcher" popular during the last decade or so among tribes outside Alaska. A thin hoop wrapped with hide provides frame for a netting of beads within. The circular format and design innovations possible by varying the size and shape of the netted openings allow a wide scope for experimentation. Suncatchers range from tiny ones to be worn as earrings to others as large as a foot or so across to sparkle when hung in a window.[3]

Earrings with hanging sections constructed using a netted technique called brick stitch are also currently popular. As in the lower forty-eight, women often refer to booklets of brick stitch earring designs sold in bead stores. Some work directly from them, others experiment.

In the late 1980s the Council of Athabascan Tribal Governments (CATG), a consortium of Yukon Flats communities, began sponsoring group workshops to encourage craft production. Both long experienced and new beadworkers met together at Fort Yukon to share ideas and inspiration, and to learn new techniques. Later workshops trained master teachers who were then sponsored by CATG to teach the making of traditional items like pointed-toe moccasins (now sometimes called canoe-style) and newer ones like suncatchers in Gwich'in, Koyukon, and Tanana communities.

Central Canadian Athapaskans attending the World Eskimo Indian Olympics have inspired new directions also, the art work they have brought to sell raising interest in new techniques and ideas. As a result, porcupine quill sewing and moose and caribou hair tufting of the type popular with Great Slave Lake Athapaskans, especially the Slavey, have been taught at recent CATG workshops. A round wooden, hide-covered jewelry box I recently saw for sale was made by a workshop member who had combined designs in couched beads, caribou tufting, and folded quillwork. It is too early to know whether the current experimentation of Gwich'in beadworkers fueled by the sharing and blending of new techniques and designs that CATG workshops have encouraged will mature into new, identifiably Gwich'in styles.

Since the 1988 publication of the first edition of this book the very limited literature concerning Northern Athapaskan art has expanded, slowly bringing the art to a wider audience. Early quilled and beaded garments from Alaska (a few of them

2. The Celia Totus Company was begun in the early 1970s by Celia Totus, an accomplished beadworker living on the Yakima Reservation in Washington State who sold patterns at powwows and other tribal gatherings. It was taken over after her death, and continues publishing patterns today.

3. See "Arctic Glitz," *Fairbanks Daily News-Miner*, December 27, 1992, and "Artist Catches the Sun," *Fairbanks Daily News-Miner*, October 25, 1990.

Gwich'in) appear in Fitzhugh and Crowell *Crossroads of Continents, Cultures of Siberia and Alaska* (1988), Varjola *The Etholen Collection* (1990), and Graburn, Lee, and Rousselot *Catalog Raisonne of the Alaska Commercial Company* (1995). A dedicated section in *Hunters of the Northern Forest* (1995) include turn-of-the-century and slightly later work.

Several books that consider Gwich'in work in context of other Northern Athapaskan art have also been published. My *Northern Athapaskan Art, a Beadwork Tradition* (1989) discusses both quillwork and beadwork of the Gwich'in. In *Out of the North, the Subarctic Collection of the Haffenreffer Museum of Anthropology*, coauthored with Barbara Hail (1989), we included extended discussion of several 1890s pieces documented as Gwich'in. Judy Thompson pictures Gwich'in examples in her essay "No Little Variety of Ornament" in *The Spirit Sings* (Calgary 1987). Recent collaborative work with MacKenzie River beadworkers (some of them Gwich'in) is the basis for her book *From This Land: Two Hundred Years of Denes Clothing* (1994).

Since the writing of this book several more public and private Gwich'in collections and individual examples have come to my attention, some in unexpected ways. I was alerted to the altar cloth at New York City's Cathedral Church of St. John the Divine (Plates 13, 14, and 15) by a book dealer in Juneau, Alaska, who came across a letter about it in a book that came into his store. Serendipity found me in the library of the Heard Museum in Phoenix, Arizona, at just the moment that a museum volunteer arrived with a curious beaded item she had just acquired—the round thank-you panel beaded by the women of the Yukon Circle (Plate 14).

As is the case with other Alaska Native art, Gwich'in examples in museums tend to be on the West Coast. There are several important Gwich'in pieces at the Cheney Cowles Museum in Spokane, Washington, and a fine group of beaded pillow covers, table covers, and wall pockets made in Circle, Alaska, about 1900 to 1920 are a part of the collection of the High Desert Museum in Bend, Oregon. Eunice Carney donated several pieces from her personal collection to the McBride Museum in Whitehorse, Yukon Territory. Those examples she and I collected in 1982 for the Taylor Museum in Colorado Springs are now in the Thaw Collection of the Fenimore House Museum in Cooperstown, New York.

Preface and Acknowledgments ✳ 1988

Bead embroidery has long been the most important art of the subarctic Kutchin. Materials, designs, and items beaded have changed over the years, but the role of the art has remained constant. This study first details the history of Kutchin beadwork, focusing on regional differences in earlier times and on information about old types now only remembered. It then considers the art today: how it is taught and learned, what is produced, aesthetics, and individual and community differences ins tyle.

This study is the result of a fieldwork trip funded in 1982 by the Urgent Ethnology Fund of the Canadian Ethnology Service of the National Museums of Canada, a program vital in the struggle to record aspects of the history of Canadian Native peoples that may soon be lost. Eunice Carney and I are deeply grateful to have had the opportunity of this project. I also wish to thank the Wenner Gren Foundation for financial support in the processing of the field data and Gary Holthaus and the Alaska Humanities Forum for funding this publication.

Most essential to the success of the study was the cheerful acumen, encouragement and adept interview technique of Eunice Carney who I count as one of my most cherished friends. She had not planned to take up a career in anthropology in her seventies, but our knowledge of Athapaskan art is richer because she did. Eunice and I worked as a team during the research trip. Afterward, in the writing of this report in 1984 and in its minimal revision in 1988, she was my constant consultant on a range of matters. Her knowledge, insights, and suggestions have been invaluable to me and her own written observations form an important section of this study.

Eunice and I are indebted to the many women and men with whom we talked. You opened your homes and your memories most graciously. It was a joy to share your pleasure in remembering and to have the privilege of bringing back to you through photographs a portion of your culture and heritage to which you have had little recent access.

In Alaska we thank: Sarah Malcolm of Eagle; Angela Harper, Sally Hudson, Lily Pitka, and Hannah Solomon of Fairbanks; Laura Alfred of Nenana; Virginia Alexander, Martha Flitt, Annie and Arthur James, Margaret John, Elliot and Lucy Johnson, Sarah Knudson, Abbie Peter, Julia Peter, Louise Peter, Minnie Peter, Titus Peter, and Doris Ward of Fort Yukon; Martha James, Mary John, Bertha Ross, Alice Peter, Josephine Peter, Gini Sam, and Isaac Tritt, Sr., of Arctic Village.

In Canada we thank Ellen Abel, Sara Abel, Martha Benjamin, Agnes Charlie, Martha John Charlie, Nancy Flitt, Annie Fredson, Clara Frost, Stephen Frost, Myra Kaye, John Kendi, Myra Moses, Joanne Najootli, Mary Tizya, Moses Tizya, and Ross Tizya of Old Crow; Mary Firth, Olive Itsi, Florence Peterson, Susan Peterson, Sarah Simon, and Louise Snowshoe of Fort McPherson. A list of Kutchin people interviewed is found at the end of this report. Those now deceased are indicated.

The trip also involved interviews in non-Kutchin Athapaskan communities on the Mackenzie River and Great Slave Lake. Information thus gathered is included in this study as relevant, but most is being incorporated into other publications. We thank Mary Blackduck, Madeline Judas, Elizabeth LaCord, Elizabeth Mackenzie, and Vital Thomas of Fort Rae; Rita Cli, Cecilia Lafferty, Celine Lafferty, Jean Loua, and Rosie Tsetso of Fort Simpson; Mary Krause of Little Doctor Lake; Gabe Denetre, Berna Landry, and Lisa Loutit of Fort Providence; Ruby Mackie of Hay River; Christine Balsillie, Caroline Fabian, Rosa Fabian, and Father Louis Menez of Fort Resolution; Jane Dragon, Bernedette Mercredi, Louis Mercredi, and Brother Sarreau of Fort Smith; and Sisters Kristoff, Champeaux, and Cooper of Edmonton.

Many government and museum people, colleagues, and friends assisted in making arrangements for the field work. We wish to thank Paul Schwartz for preparing the large color prints we took along and the photographs for this report; Erik Bilello for innumerable errands; Jeff Leer of the Alaska Native Language Center, University of Alaska Fairbanks, for assistance with linguistic transcription; Dave Sutherland of the Canadian Arts and Crafts Board, Yellowknife, for sharing his collection and experience; and Virginia Alexander, Doris Allen, Mary John, Nina Bergman, Hannah and Grafton Bergman, Rita Dahlke, Mary Firth, Trudy Nicks, Turid and Ron Senungetuk, and Barbara Winter for hospitality. For assistance in arrangements we are also indebted to June Helm, Julie Cruikshank, and Virginia Alexander, and to the staffs of the Institute of Alaska Native Arts, Fairbanks; the University of Alaska Museum, Fairbanks; the Prince of Wales Northern Heritage Centre, Yellowknife; the Netsenalu Society, Fort Simpson; the Native Women's Association, Yellowknife; and the Fort Smith Museum.

I wish also to thank the Division of Art History and the American Indian Studies Program of the University of Washington for assistance while analyzing the data and writing this report and Zandra Apple, Elise Kritsis, James Wilson, Becky Kwan, and Lisa Corey for transcribing field tapes. In addition, thanks to Nancy Corbin, Lucy Driver, Barbara Hail, Judy Proller, and Jan Steinbright for reading the manuscript. Any mistakes and omissions, however, are my own.

—*Kate Duncan*
Seattle University
1988

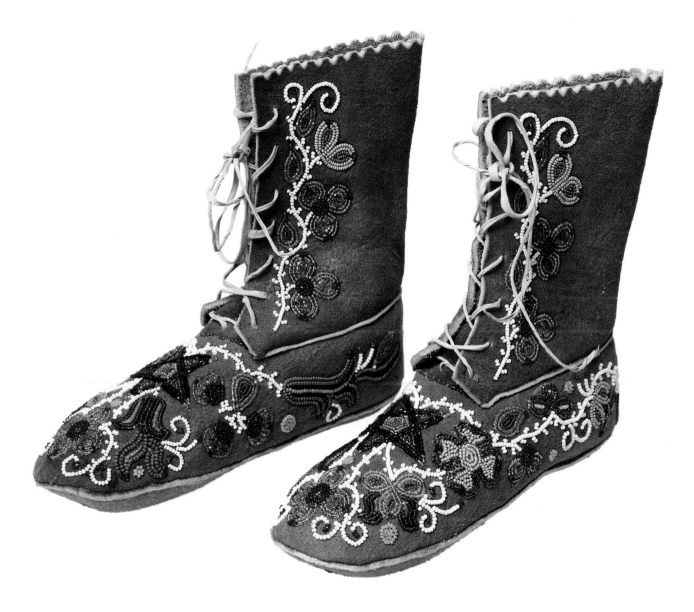

Plate 1 Dance boots, Kutchin, made in 1986 by Eunice Carney. Hide, seed beads, metal beads. For this commission from the
Newark Museum, Eunice used a part of the last hide that her mother had tanned. Newark Museum, New Jersey, 86.32.
Photograph courtesy Newark Museum.

I

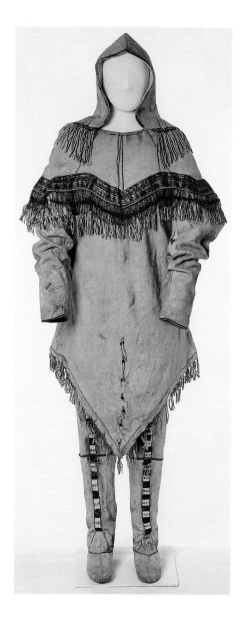 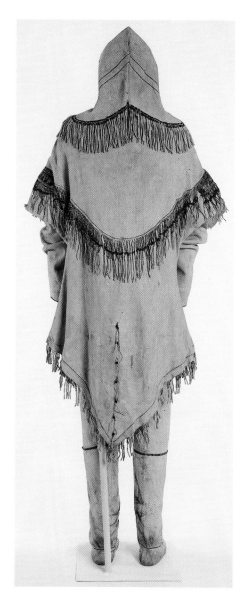

Plates 2, 3 Quilled summer outfit, Kutchin, 1882–1883. Hide, porcupine quills, eleagnus seeds, red ochre. This typical summer outfit includes a tunic, separate hood, moccasin trousers, mittens, and a knife sheath. Although acquired by Captain Henry Philip Dawson while on an astronomical expedition at Fort Rae on Great Slave Lake, it was made further west. This and similar outfits in several museums seem to have been made for sale by Canadian Kutchin women. Eugene and Claire Thaw Collection, Fenimore House Museum, Cooperstown, New York, T237.

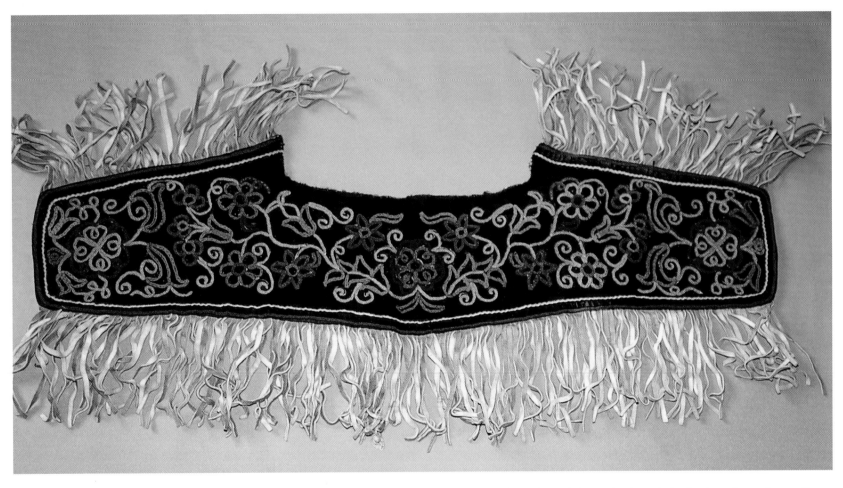

Plate 4 Yoke for jacket, Old Crow area, 1910–20. Velvet, *niltłyaa*, hide. A jacket yoke normally is a part of a set that includes a yoke, front placket bands, and sometimes cuff and/or pocket bands. Embroidered units are often removed from a worn jacket and reused on a new one. See fig. 14. Private collection.

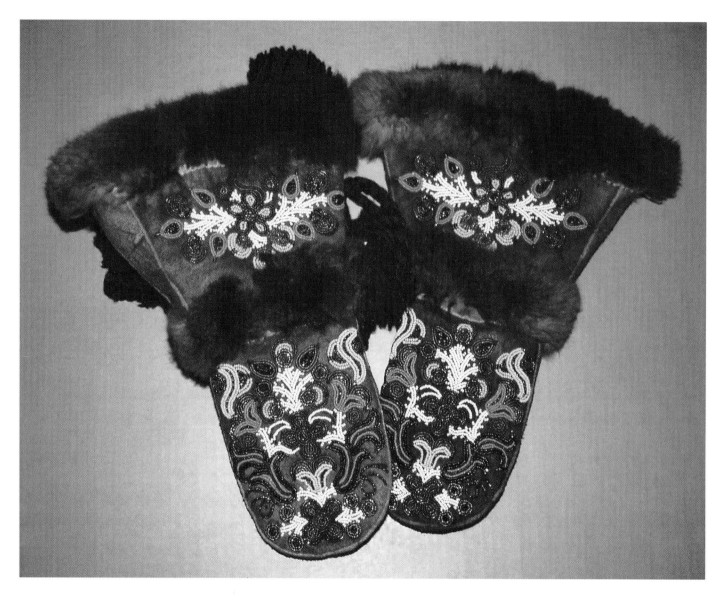

Plate 5 Mittens, Kutchin, Fort Yukon, 1920s. Hide, seed beads, metal beads, and beaver fur. A number of mittens with similar beaded patterning were made about 1920. Cheney Cowles Museum, Spokane, Washington, 1740.2. Received in 1961 from Hugh B. Laughlin. See fig. 63.

4

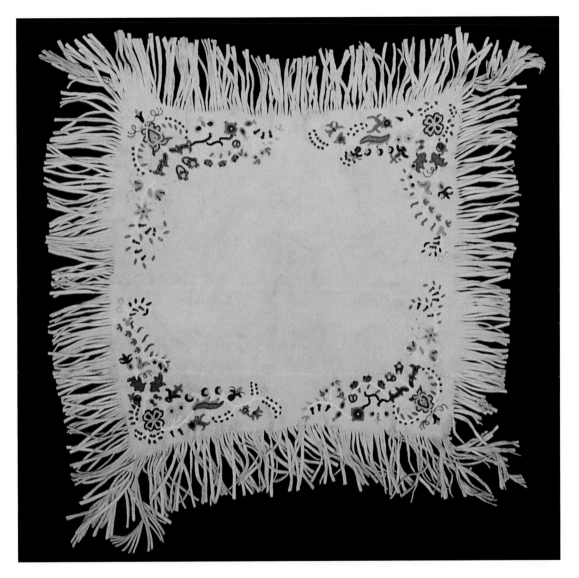

Plate 6 Table cover, 39" x 35", Circle Hot Springs, 1900–1920. This large table cover belonged to the Jewetts who
ran the lodge at Circle Hot Springs. Early in the 20th century beaded table covers and pillows of hide were
created for sale to visitors who traveled up the Yukon. The greatest number were made by Han women at
Eagle and Dawson, but the Jewett collection includes several Kutchin examples. Such decorative, serviceable
items were also popular among Alaskans who liked to decorate their homes with local handicrafts. Bounds
Collection, High Desert Museum, Bend, Oregon, 9.3.1.

5

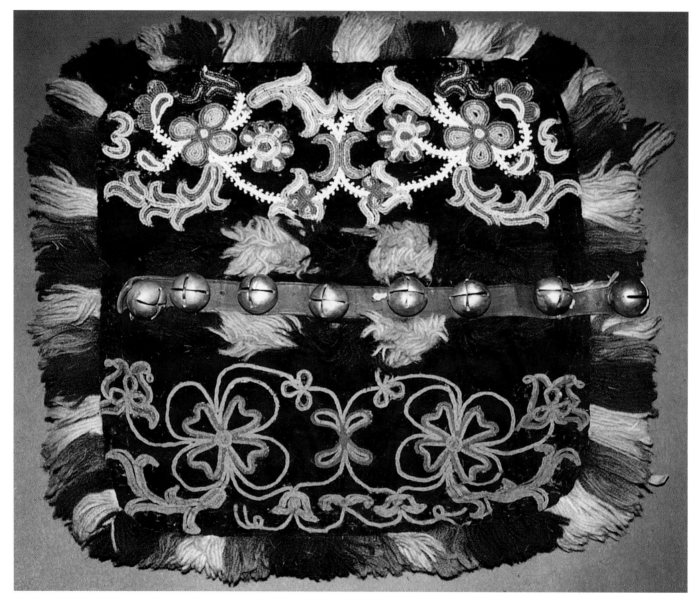

Plate 7 Dog blanket, Kutchin, early 20th century. Velvet, seed beads, metal beads, *niltłyaa*, yarn, and sleigh bells mounted on leather. The dog blankets of this set are unique in their use of different materials on each side. National Museum of the American Indian 16/1667. M. W. Pope Collection.

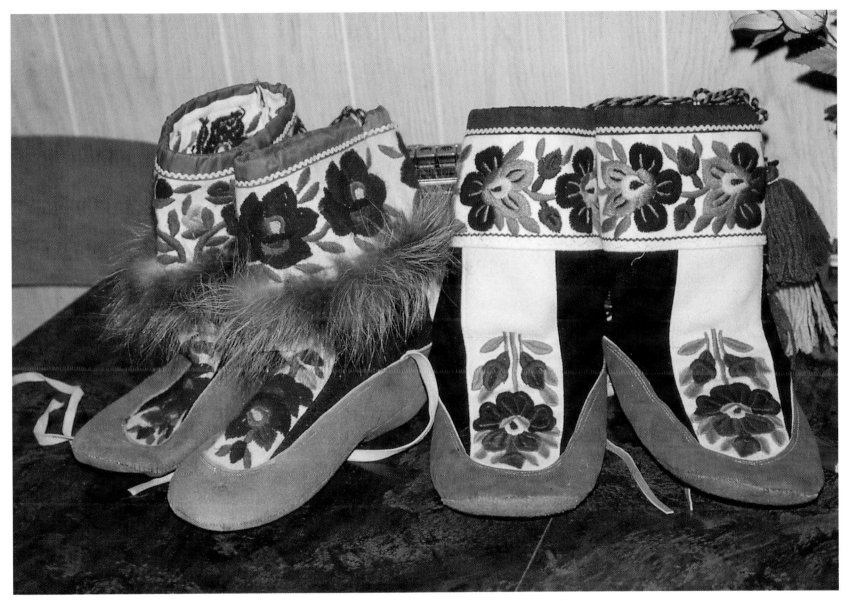

Plate 8 Boots, Fort McPherson, 1982, made by Susan Peterson. Hide, duffle, wool yarn embroidery. See fig. 58.

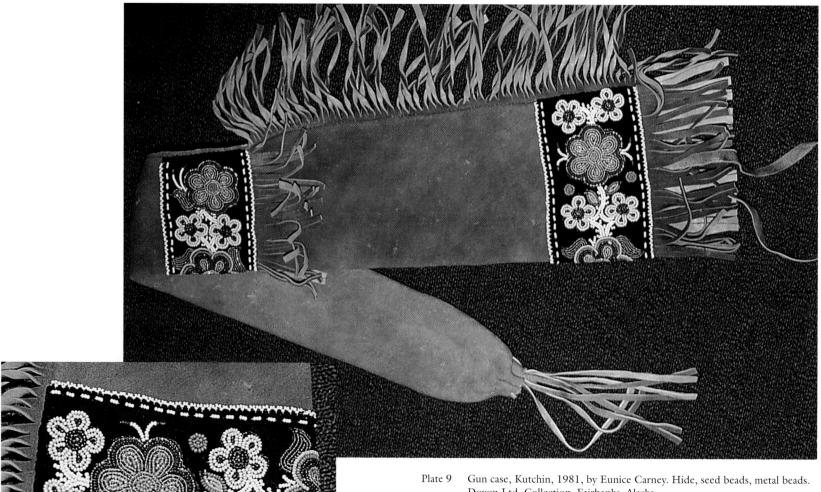

Plate 9 Gun case, Kutchin, 1981, by Eunice Carney. Hide, seed beads, metal beads. Doyon Ltd. Collection, Fairbanks, Alaska.

8

Plate 10 Detail from gun case, 1981.

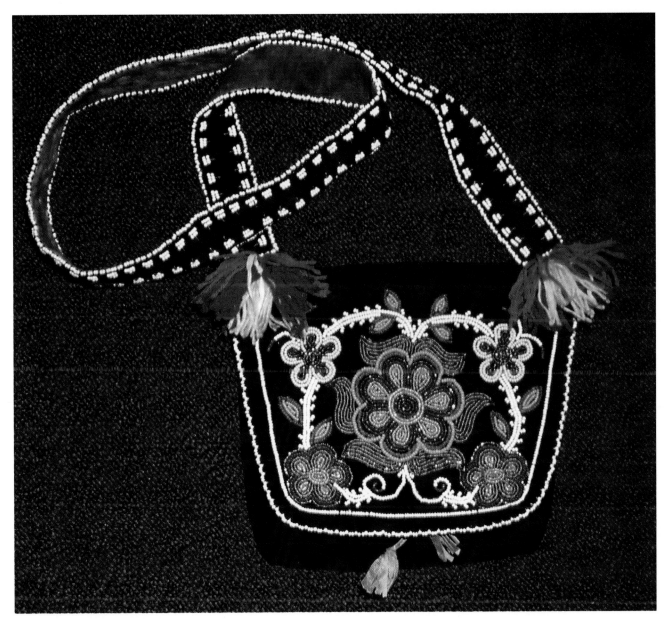

Plate 11 Shot pouch, Kutchin, 1981, made by Eunice Carney. Velvet, seed beads, metal beads, wool yarn. Gun cases and shot pouches were sometimes made to match. Doyon Ltd. Collection, Fairbanks, Alaska.

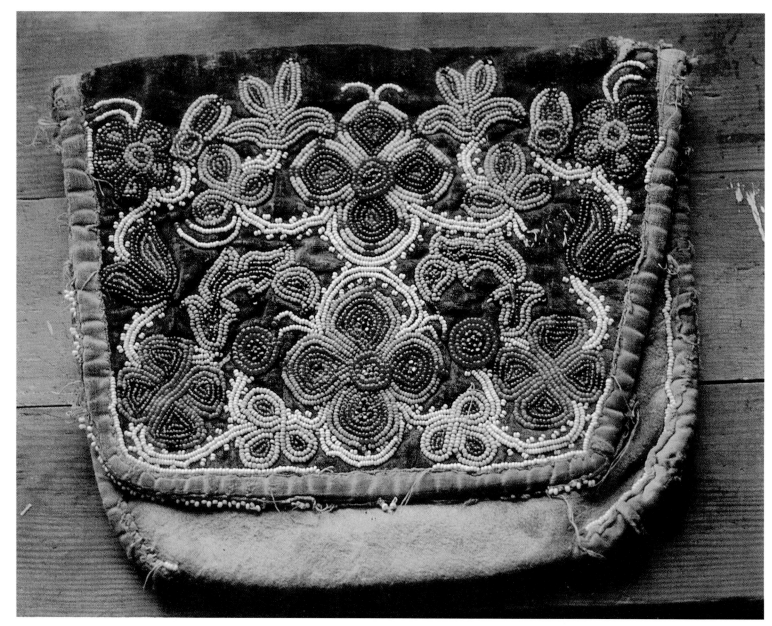

10 Plate 12 Pouch, Fort Yukon, Alaska, early 20th century. Hide, seed beads, metal beads, fabric. See fig. 73.

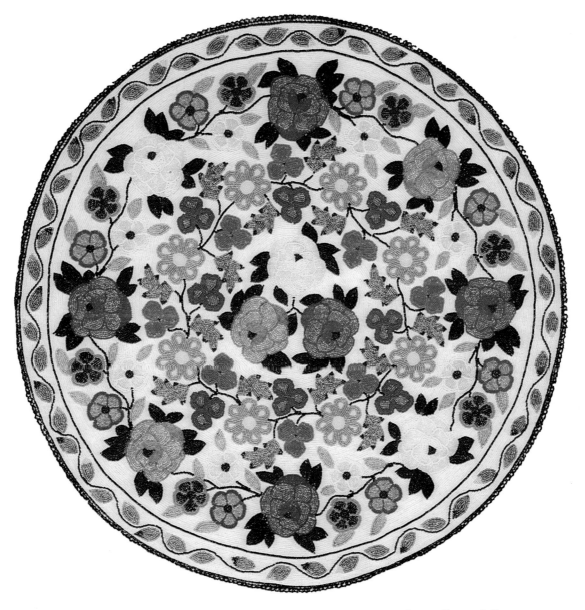

Plate 13 Circular hanging, Jeanne Stevens, Bettles, 1984. Seed beads on canvas. Ms. Stevens likes to challenge
herself with unusual forms and subject matter. In the late 1980s, she beaded a map of Alaska picturing
important wild animals across its surface. Private collection.

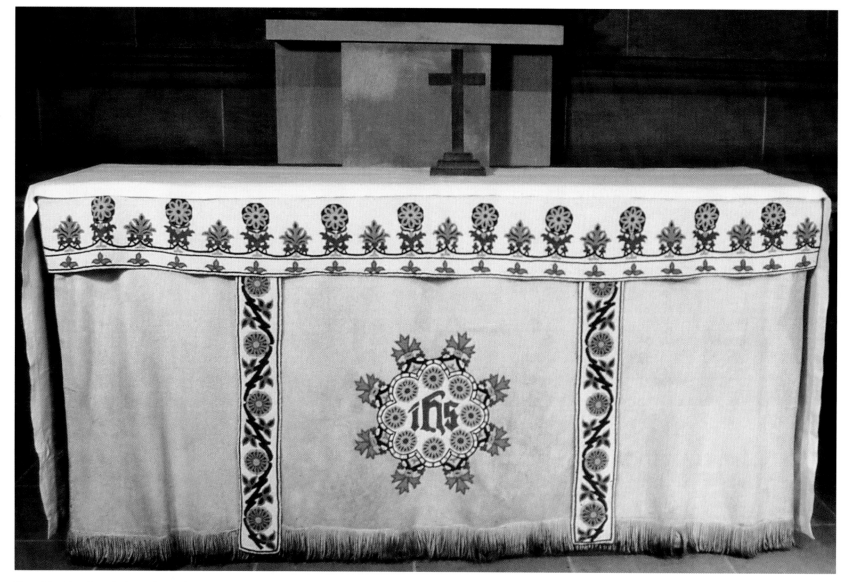

Plate 14 Altar frontal, Fort Yukon, 1930s, on display in the Native American Bay (also called the Sports Bay) of The Cathedral Church of Saint John the Divine in New York City. The hanging, of bleached moosehide, is said to include 403,920 beads (letter to Miss Florence Stuck from the Rev. Thomas A. Sparks of the Cathedral, January 4, 1940.) Presented to the Cathedral on February 8, 1931, the inscription on the underside reads: "In grateful memory of the work for our people done by Bishop Rowe and Archdeacon Stuck this hanging was made and given by the Native women of Fort Yukon, Alaska." This frontal is almost identical to one made soon after World War I that is still in use at St. Stephen's at Fort Yukon. See fig. 65. Photograph by Enid Farber.

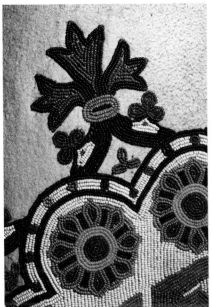

15

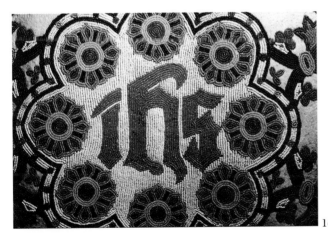

16

Plates 15, 16 Details from the altar cloth at The Cathedral Church
of Saint John the Divine, New York City. Photographs by
Enid Farber.

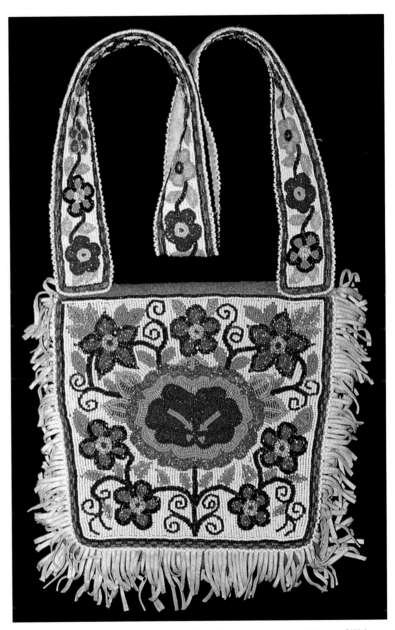

Plate 17 Man's prayer bag, Aklavik, 1950s. Holman Collection, Prince of Wales
Northern Heritage Center 979.63.2.

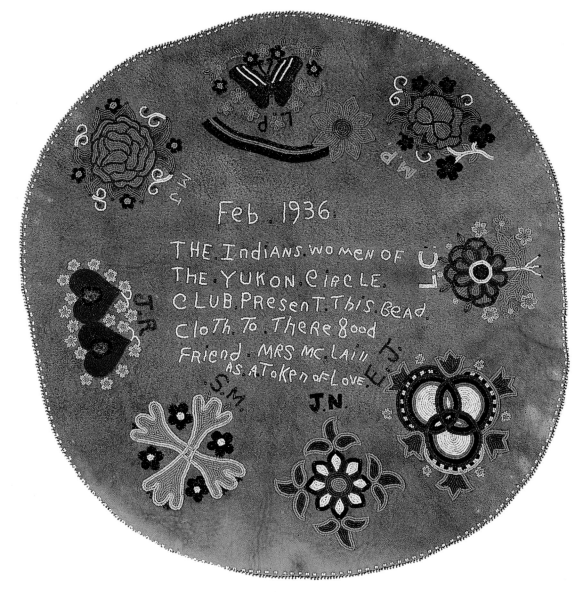

The text beaded on the panel reads:

Feb . 1936 .

THE Indians women OF
THE YUKON Circle
CLUB Present This Bead
Cloth To There good
Friend . Mrs Mc.Lain
As a Token of Love .

L.P. M.P. L.C. J.R. S.M. J.N. E.J. M.J.

Plate 18 Circular thank-you panel, Yukon Circle, 1936. Some of the motifs appear also on the early altar cloths made by the Fort Yukon church St. Stephen's. Photograph courtesy The Heard Museum, Phoenix, Arizona.

14

Introduction

Among the Kutchin, a gift of ornamented clothing is a special gift. Making beautiful the clothing of one's loved ones by adding fantasies of flowers and color has been important to Kutchin women for over a century. A beaded jacket or pair of moccasins is more than simply a garment—it is a visible symbol of generosity of spirit, of one's joy in creating, of one's time and fond attention.

Beadwork is an extension of a tradition of garment ornamentation shared by all of the Northern Athapaskan groups and extending into prehistory. The Kutchin, in earlier years expert quill workers, have for over a century been among the most active of the Athapaskan beadworkers. The art remains vital today and the tradition reflects both continuity and change.

In the summer of 1982 Eunice Carney and I had the privilege of traveling together to study Kutchin beadwork. The purpose of the trip was to increase knowledge of the beadwork style of the Kutchin, the westernmost people of the Great Slave Lake–Mackenzie River style region, and, through collaborative discussion with Natives, to verify conclusions reached previously via style analysis of museum material and historical research (Duncan 1982; 1988). We hoped to come to a more exact understanding of the relationship of Kutchin design with that farther east in the region, and to come away with new information on the beginnings of Kutchin beadwork, and the nature of design diffusion to and across the Kutchin area. We also planned to gather information on current day aesthetics, standards of quality, teaching–learning relationships, and transfer of ideas and designs.

A basic goal of our trip was to provide Athapaskan people access to parts of their heritage by giving them the opportunity to examine large color photographs of beadwork which had left their communities years earlier. This, in turn, could furnish stimulus to the present tradition, allowing women to observe older solutions in matters of cut, construction and beadwork design.

The seven week research trip pooled the talents of the author, a non-Native scholar trained as an art historian, with those of a long-time Kutchin beadworker, Eunice Carney. Eunice and I worked together in interview situations. We carried with us slides and a group of forty 11 x 16″ mounted color prints of Kutchin and related beadwork, sharing them with whoever wished to see them, and recording in notes and/or on tape the observations of the older people. Individual interviews were held with all elderly who were available and interested. If a slide presentation was desired in a community, it was arranged through the local museum, band council or old folks home. In most communities such presentations were attended primarily by young to middle-aged women; in Arctic Village the audience was mostly men. In all communities visited throughout the trip, prearrangements proved to be of limited value since people's summer plans changed quickly.

The trip itinerary included Kutchin communities in Alaska and the Yukon Territory, larger communities where many Kutchin women now live, and the major Native communities in the area of Great Slave Lake. Since many Kutchin now live in Fairbanks or Whitehorse, we visited both. The most concentrated work was done, however, in Fort Yukon, Arctic Village, Old Crow, and Fort

15

McPherson. Venetie was not included because the people we hoped to see were away. Across the north the elderly who are not infirm love to travel. Some who were not at home were encountered as we visited in another village.

Although the work in communities around Great Slave Lake was less inclusive because of the several language groups involved, and because research objectives focused on the Kutchin, the time there yielded information important both to those major research objectives, and to understanding of the beadwork traditions of Great Slave Lake groups. We held both group and individual interviews in the Dogrib community of Rae-Edzo, the Slave communities of Fort Simpson, Fort Providence, and Hay River, and in the Chipewyan communities of Fort Resolution and Fort Smith.

There has been much intermarriage between Natives and non-Natives across the north so that by now many people are to some degree of mixed blood. Only around Great Slave Lake did some of those we talked with think of themselves as Métis, however. In Kutchin communities people think of themselves as Indian and call themselves either Kutchin or Loucheux, and those identifications are used here.

The following focuses on the Kutchin, with information from other groups included as pertinent. Unless otherwise noted, all the photos are from slides taken by Kate Duncan during the summer of 1982 or in museums in 1977. Beadwork specimens without museum identification are all in private hands.

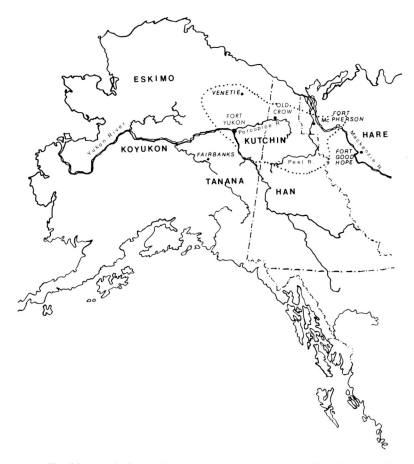

MAP Kutchin people live today in the area traditionally utilized by their forefathers.

The Kutchin are the Athapaskans of the Middle Yukon, the Peel and the Porcupine Rivers.[1] Their traditional territory stretches from the Mackenzie River delta or flats east of Fort McPherson in the Northwest Territories, west to just beyond Fort Yukon in Alaska. On the east they border the Hare. To the west and south live the Athapaskans of the upper Yukon, the Tanana and Koyukuk rivers: the Tanana, Han, northern Tutchone, and Koyukon. To the north live the Eskimo.

The word *Kutchin* is actually a suffix that means "dwellers at". Native groups often joined it to geographic terms such as *Gwichaa* and *Dagoo* to identify groups from specific locations. Early visitors to the region picked up the word and sometimes attached it to others who did not actually speak Kutchin. In attempting to sort this out, Osgood (1934) and others have distinguished eight to ten true Kutchin divisions from several others erroneously identified as such in earlier literature.[2] Each speaks a Kutchin dialect but identifies both physically and culturally with each other and as separate from the other Athapaskan-speaking groups.

In the earliest literature the French traders' name *Loucheux* was used specifically to designate the eastern Kutchin who lived on the Mackenzie River delta. Although some later writers such as Har-

disty and Cadzow used the term more broadly to mean all of the Kutchin, more recent research, particularly that of Osgood, McKennan, Balikci and Slobodin, has verified the east-west division that was earlier noted. Slobodin (1964, 1966) identifies it in the communication networks of both full and mixed bloods in the twentieth century. Today, the name Loucheux is used by the Canadian government for Canadian Kutchin-speaking peoples, those of Fort McPherson, Arctic Red River and Aklavik, although some prefer to be called Kutchin. The people of Old Crow like to call themselves Loucheux, although most are Vunta (Vantat) Kutchin, a group which Osgood saw as western. (The strongest ties reflected in Old Crow beadwork are with that from Fort Yukon farther west.) West of Old Crow, people call themselves Kutchin.

Since the time of contact, relationships and distribution within the eastern and western Kutchin areas have been based on affiliation with particular trading posts. Osgood (1934) identified the eastern Kutchin as those of the Mackenzie Flats River (Nat-kotcho), the Peel River (Tatlit) and the Upper Porcupine River (Takkuth).[3] They traded at Fort Good Hope and Peel River Post until the more convenient Fort McPherson was built in 1840. Since then, Fort McPherson has been their major post except during brief periods when neighboring posts were used in protest of policies at McPherson (Petitot in Savoie, II, 1970:05; Stewart 1955:265).

The western Kutchin groups identified by Osgood are the Crow

1. Other designations and spellings common in the literature are Kootchin, Dindjie; Loucheaux, Louchoux.

2. The groups erroneously called Kutchin in the literature but determined by Osgood (1934) not to be Kutchin are the Atai Kutchin (Mountain), Batard-Loucheux (a Hare band), Han-Kutchin (Han), Upper Yukon Kutchin (Tutchone), Lower Yukon Kutchin (likely the Tatsan or Tetsi, possibly a Kutchin group but now extinct), Tenah-Kutchin (Tanana) and the Tehanin-Kutchin (Tanaina).

3. See Richard Slobodin, "Kutchin" in *Handbook of North American Indians: Subarctic*, Vol. 6 (Washington, D.C.: Smithsonian Institution, 1981), pp. 514–532, for discussion of more recent analysis of Kutchin divisions and their names.

River (Vunta), Black River (Tranjik), Yukon Flats (Kutcha), Birch Creek (Tenuth) and Chandalar River (Natsit) Kutchin. More recently, other groups such as the Dihai and Nakotcho have been identified.

With its construction in 1847 at the confluence of the Yukon and Porcupine Rivers, the British-owned Hudson's Bay Company's Fort Yukon became the major trading post for western Kutchin groups. After the purchase of Alaska in 1867 by the United States, the Hudson's Bay store at Fort Yukon was closed and moved east several times in efforts to be sure it was located in Canadian territory. It was eventually closed altogether. The community of Fort Yukon remained an important trading location, however, served by a main store run by the Alaska Commercial Company as well as additional small private trading enterprises. Rampart House, on the Porcupine River just east of the Alaska-Canada border, was important until the 1920s when the people there moved about eighty miles east and established the community of Old Crow.

There has always been contact between the eastern and western Kutchin. In early years some western Kutchin traveled the long distances to Peel River Post and Fort MacPherson twice yearly to trade. The trip included both river and overland portions and could be arduous. Fort Yukon was established in 1847 to provide a post in western Kutchin country. Whole families were less apt to travel, and even in the early years of the twentieth century a visit from a McPherson family to Old Crow was an event. Even today the air trip is too expensive to happen often. Relatives and friends keep in contact via the mails and telephone but may rarely see each other.

LITERATURE

What is known of the earliest Kutchin art is based on descriptions of the people in the early literature and examples in museum collections. There are more eighteenth and nineteenth century reports which refer to the Kutchin than there are for most Northern Athapaskan groups. Alexander Mackenzie talks of Loucheux groups (calling them the Quarrelers) in the account of his exploration in 1789 to the mouth of the river that now bears his name. In early to mid-nineteenth century reports, Franklin, Simpson and Richardson also mention the eastern Kutchin. They are described even more fully in Petitot's various writings later in the century.

Among first Europeans to meet the western Kutchin were Russian traders and explorers. By early in the nineteenth century, a few had ventured partway up the Yukon River and had encountered Kutchin at Nuklukayet, a major Native trading location on the Middle Yukon River, but most never went beyond the lower river and the Russian posts established there among the Ingalik and Koyukon. Although a few Kutchin occasionally came that far downriver to trade (Wrangell 1839 [1970]; Zagoskin 1842–44 [in Michael 1967]), Russian accounts give little information about them.

In 1847, at the direction of the Hudson's Bay Company, Alexander Murray established a post called Youkon Fort at the junction of the Yukon and Porcupine Rivers. Murray's lively *Journal of the Youkon* (1910), written during 1847–48, describes in detail his experiences with the Natives, mostly Kutchin, who frequented his post, and includes his drawings of them in costume.

In 1865, less than two decades after Murray wrote, the Western Union Telegraph Expedition was inaugurated. Expedition members were to survey a route suitable for the establishment of a telegraph line from San Francisco and across Russian America and the Bering Sea to connect at the Amur River with a Russian line across Siberia. The project was abandoned within two years due to the success of a new Atlantic cable, but it had already made a major contribution to science through the important data collected by its personnel, a group of young men who had been asked to double as the United States Scientific Corps. Soon after their travels of 1866–67 with the Telegraph Expedition, two of these men, Frederick Whymper (1869) and William Dall (1870) pub-

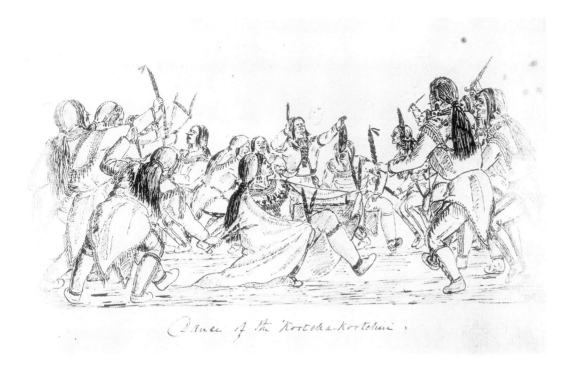

Dance of the Kootcha-Kootchin.

FIGURE 1 Drawing, "Dance of the Kootcha-Kootchin," by Alexander Murray, 1847–48, in his *Journal of the Yukon*, published in 1910 with engravings based on the drawings. At mid-century Kutchin men at the fort all wore the pointed tunic and moccasin trousers. The man at the far left has slung a *naki eik* over his back shoulder in bandolier fashion, while a central figure dances with a dentalia-ornamented knife sheath at his neck and a tobacco pouch in his belt, and two on the right wear bead and dentalia necklaces.

lished entire books on their experiences.[4] Their, and other information gathered over the next thirty years as a part of several government sponsored surveys considerably increased knowledge of both the natural history and the Native peoples of the region, particularly in the areas along the Yukon, Copper, and Kuskokwim rivers.

After its purchase from Russia in 1867, Alaska came under the

jurisdiction of first the Army, then the Treasury Department, and finally the Navy, before the First Organic Act in 1884 provided it a degree of self rule. During these years and until the end of the century, surveys and reconnaissances were sponsored by various governmental agencies such as the Signal Service, the Coast and Geodetic Survey, the Army, and the United States Geological Survey. These were designed to gather a range of information to help determine possible uses for and potential problems of this remote area which many regarded as a worthless "icebox."

Although the reports from such surveys include far fewer ethnological observations than do the writings of Dall and Whymper, those surveys which mention the Kutchin are worth noting. These include the reports of Jones (1866) and Hardisty

4. Dall's field notes, diaries, and field drawings are in the Smithsonian Institution Archives. Some Whymper drawings are located in the Bancroft Library, Berkeley, but most are at present unaccounted for. The ethnographic collections in the Museum of Natural History, Smithsonian Institution, include Kutchin ethnographic specimens collected by Kennicott and Dall on the Telegraph Expedition and others of about the same date from both Hudson's Bay personnel and staff of various government related expeditions.

(1867) of the Telegraph Expedition, and of Raymond's Yukon reconnaissance of 1869 (1873, 1900), Schwatka's of 1883 (1885, 1900), Allen's of 1885 (1887) and I. C. Russell's of 1889 (1895). The Kutchin are also mentioned in accounts from the United States Boundary Survey Exploration of 1887–88 under G. M. Dawson (1889), Ogilvie (in Dall, Dawson and Ogilvie 1898) and McConnell (1891), and in the mineral surveys of the 1890s. Nelson met and photographed Kutchin while studying the Eskimo about Bering Strait in the late 1870s.[5]

5. Nelson's Kutchin photographs are located in the National Anthropological Archives, Smithsonian Institution.

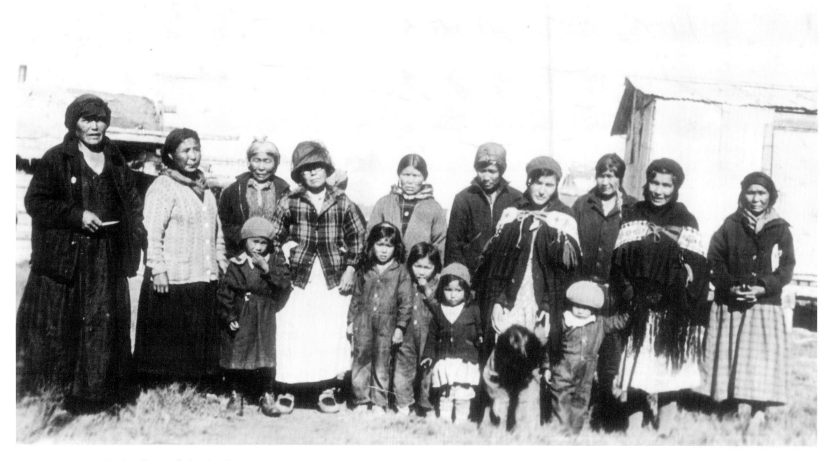

FIGURE 2 Women's Auxiliary of the Anglican Church in Old Crow, Yukon Territory, ca. 1935. The women are, left to right: Myra Kaye (Big Myra), Myra Moses (Little Myra), Eliza Steamboat, Bysis Kendi, Eliza Ben Kassi, Ellen Bruce, Caroline Moses, Ellen Abel, Clara Tizya, and Sarah Balaam.

Sometime in the eighteenth century beads were introduced to Natives along the coast of Russian America via the Russian fur trade. Captain James Cook found them to be established items of barter when he visited Prince William Sound in 1778. At that time, blue and green beads were especially valuable (Beaglehole 1967, Part 1: 346). By the 1830s when Zagoskin visited the mouth of the Yukon, beads and dentalium shells were prominently displayed on the clothing of the wealthy there, and both were coming to be coveted trade items in the interior. Zagoskin observed that among several western Athapaskan groups, particularly the Kutchin, successful men wore broad bands of beads and dentalia several yards long and weighing as much as ten pounds, around the neck or over the shoulder (Zagoskin in Michael 1967: 246). The Kutchin called the bands *naki eik* (bead clothing). According to Strachan Jones (1866: 77), one *naki eik* was equal to twenty-four "made beaver."

Franklin and Mackenzie both noted eastern Kutchin enthusiasm for beads, and post records verify this through the middle decades of the nineteenth century. As farther west, they were for a time used as a means of exchange, so were wealth. Owning beads allowed the activities that increased social standing and wearing them advertised it.[6]

Sarah Simon of Fort McPherson was born about 1907. She

listened as a child to her grandmother, Kathryn Stuart, as she talked about the early use of beads on the lower Mackenzie. Kathryn, an eastern Kutchin, was married to a Scots Hudson's Bay employee. The information she related to Sarah corroborates the presence of large beads originating with the Russians before the smaller seed beads became available.

Before that [the arrival of the Hudson's Bay Company] nobody knows about beadwork. Nobody knows nothing about beads, because everything is skin, but they do know all different ways to sew. Before the Hudson Bay people came along, olden days, she said that some kind of a people with very pretty big beads come, with their guns and they fired them [at] one another. My grandmother always say bargain, a man that can bargain beads is a wealthy man. Then his first born, his first child would wear [beads].

My grandmother said her children ask her where beads come from. She said that she think they came from Russia, because they came—the people used to bring them over from Alaska—the real good ones, they really like them.

Sarah's information that the larger Russian beads were not readily available so far east as Fort McPherson is borne out in museum collections of old style tunics, all collected from Alaska or the bordering Yukon.

OLD STYLE KUTCHIN GARMENTS

An "old style" pointed tunic and footed trousers appear to have been at one time worn by almost if not all of the Northern Athapas-

6. See the excellent article by Shepard Krech III, "The Early Fur Trade in the Northwestern Subarctic: The Kutchin and the Trade in Beads," in *Selected Papers of the Fifth North American Fur Trade Conference, 1985*, (Montreal: Lake St. Louis Historical Society, 1987) pp. 236–277. Based on extensive work with fur trade records, it details specifics of the economics of bead availability and use by the Kutchin in the middle decades of the nineteenth century.

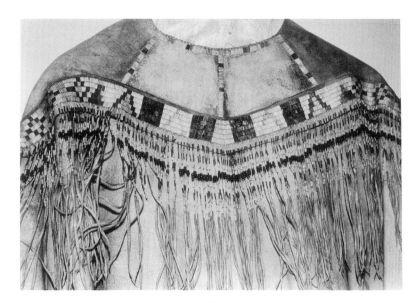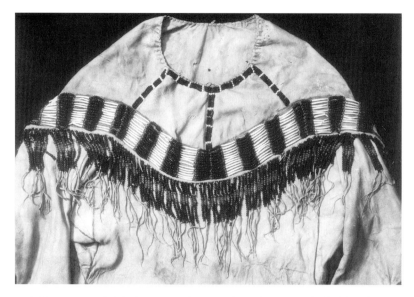

FIGURE 3 Left: Detail of yoke of quill ornamented tunic collected from the Alaska Kutchin. Caribou hide, porcupine quills, silverberry (eleagnus) seeds, glass beads. The quilled chest band is formed of several contiguous rows of folded quills attached with sinew. Bands on quilled examples collected from the Kutchin or thought to be Kutchin are created from a series of narrow fillets of folded quills rather than from quills woven on a loom or directly onto the garment. The red and blue geometric blocks grouped across the strips are typical. Given by Rev. W. W. Kirkby of Fort Simpson, 1860. Royal Scottish Museum 564A.

Right: Detail of yoke of Kutchin tunic. Caribou hide, pony and slightly larger beads, dentalium shells, red ochre. Collected ca. 1860 by Gaudet. Smithsonian Institution, National Museum of Natural History, Department of Anthropology 4971. Photograph courtesy Smithsonian Institution.

kans, although distribution among southern border and eastern groups is not clear. While eastern groups had abandoned such garments by the nineteenth century, many western groups still wore them well through the century. Examples in museum collections were acquired in Alaska, primarily from the Kutchin, Tanaina, and Ahtena. The old style costume is the only type that Murray described as being worn by the Natives about Fort Yukon in 1847–48. The western Kutchin gave it up only gradually and somewhat reluctantly in the later part of the century as trade fabrics and European-cut garments became available and popular.

The "old style" Athapaskan tunic is tailored of several skins. The back piece is cut to fold over the shoulders and attach to the front in diagonal seams that run away from the center at the neck and then angle up and over the lower shoulder. Long sleeves are seamed in, usually with gussets. The adult tunic is normally ornamented with a wide breast band of quills, trade beads, or beads and dentalium shells, curving across the front and ending just over each shoulder. Below the band hang long, very thin fringes cut diagonally from a narrow strip of skin, then twisted and partially wrapped with dyed porcupine quills and strung with eleagnus seeds or trade beads. A similar, often sparser fringe dips in a deep curve across the back of the garment. The diagonal neck seams in the front are

covered with a narrow band of beads or quills or are delineated with red ochre. Cuffs are usually edged with a narrow decorative band.

The cut of the hem, especially on female tunics, apparently varied among different Athapaskan groups. Murray (1910) pictures the male summer tunic of the Kutchin as pointed in both front and back and that of the female as straight in the front and pointed in back. Kutchin winter tunics (those with the fur left on inside) in museums are cut almost straight all the way around but with a bit of a dip in the back. Whereas the hems of pointed tunics, Kutchin and otherwise, are edged with thin quill-wrapped fringes similar to those at the chest, the Kutchin straight-hemmed tunic is usually finished with a band of red ochre painted several inches above the hem then accented at intervals with bead-strung thongs, what William Dall (1870 : 83) called "tails of beadwork." This hem handling appears especially on tunics where the breast band is omitted in preference for a simple line of beads following the angled neck and shoulder seams (Duncan 1987). A few summer tunics are also ornamented this way.

Because of the presence of the Hudson's Bay Company and the mounting of expeditions along the Yukon as previously mentioned, far more old style tunics were collected from the Kutchin than from other Athapaskan groups. There are more beaded examples than quilled ones, and most of these use pony sized or larger beads. A photo taken by Nelson about 1880 of a Kutchin man encountered in the Innoko River area (National Anthropological Archives, Smithsonian Institution 6362; see Duncan 1988, Fig 4.1) documents that once seed beads became available, they were sometimes used on tunics and leggings in the same way that quills and larger beads had been.

The moccasin trousers worn with the old style tunic are long and somewhat narrow, with the feet attached. Ornament falls in a narrow band down the side or front of the leg, in even narrower bands along the ankle seams, and on garters hung at the knees.

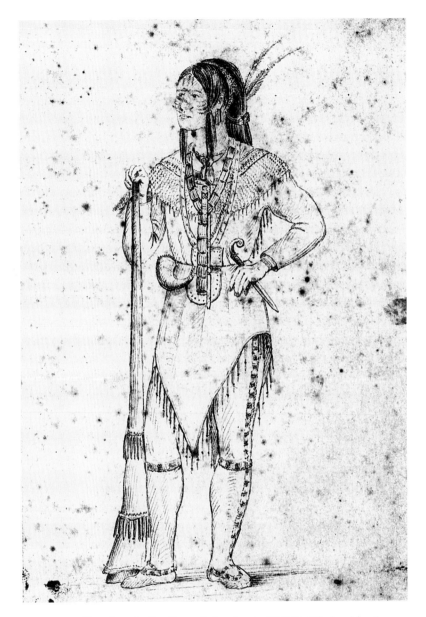

FIGURE 4 "Louchou Indian," pencil drawing by W.G.R. Hind, mid 19th century. Photograph courtesy Public Archives of Canada.

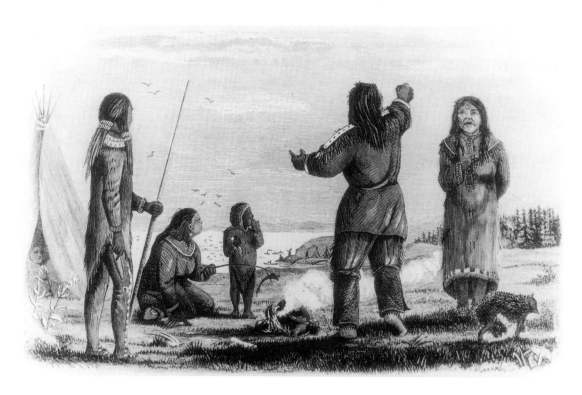

FIGURE 5 "Tenan-Kutchin and Kutcha-Kutchin," wood engraving by Henry Elliott in William Dall's *Alaska and its Resources,* 1870, opposite page 431. In 1867 both Tanana (Dall's Tenan-Kutchin) and Kutcha-Kutchin still used the pointed tunic and moccasin-trousers, but some of the latter also had English style hunting shirts and fabric leggings worn over separate moccasins.

Murray describes leg bands as often patterned with alternating blocks of red and white.

Elderly Kutchin interviewed in 1982 had heard that "the men used to wear dresses" and that they were pointed, but few had seen the type. Alice Peter of Arctic Village commented that a woman's tunic was cut at the hem "round like a curve" and a man's was pointed. Myra Kaye of Old Crow in her 90s, had not made one herself but remembered a quilled tunic that her auntie had made. According to Sarah Simon of Fort McPherson, her grandmother "said she made lots of Indian suits. And she did this kind with beads or quills . . . and lots of those pretty big beads."

The footed trousers appear to have been used even longer than the tunic. Eunice Carney's mother made them early in the twentieth century for her children when they were small. Alice Peter described the old trousers as coming to the waist to be tucked into a belt. Sarah Simon remembered old people speculating about their advantages in early times when the Kutchin were sometimes involved in warring.

This is the way my grandmother say ... they don't have separate shoes. My husband's stepfather is very old man. He used to talk about it and he said the men and the women all wear just like in

24

sleepers. They're not separate, because of the war. People attack one another and this is tidy. They wouldn't lose it. Oh, long, long time ago, long time ago.

Several older women knew how to make and quill-wrap the thin, angle-cut fringes characteristic of early Athapaskan specimens. Hannah Solomon of Fort Yukon had watched her mother twist a flattened porcupine quill around and "pull it right through" then dampen the hide so the quills would tighten as it dried. She had not tried it herself.

Myra Kaye of Old Crow remembered dying quills black or brown by tying them up in lichen and boiling them; different kinds of lichen produced different colors. Although nothing but water was used with the lichen, the dye was strong and stable.[7] According to Alice Peter of Arctic Village, rotten or "petrified" woods produce black or blue dye and crow berries can be used both for dye and as beads themselves. Quill dying turns out well if done in clear weather, regardless of the temperature, but if it is cloudy it turns out badly. Hannah Solomon of Fort Yukon mentioned that more recently indelible ink had been used to dye quills purple, and crepe paper to turn them yellow, green, or red.

EUROPEAN INFLUENCE AND GARMENTS

Alexander Murray, like other Hudson's Bay factors, encouraged Native use of fabric clothing in order that a dependency on the post would develop, one that required hunting and trapping for the Company rather than for personal needs. In his 1847–48 journal he complains about the reluctance of the Kutchin at Fort Yukon to give up their traditional dress and reports giving a "chief's coat" to a Native (Murray 1910: 59), no doubt in part to encourage the transition to European-type garments.

By the 1860s major changes had begun to take place and visitors to Fort Yukon observed a broad range of clothing being worn there. Remote groups such as the Tanana, who traded in only occasionally, still wore the old style tunic exclusively, while many of the Kutchin, in closer contact with acculturative forces, preferred garments that reflected European influence.

Frederick Whymper (1869: 210) described a group of Kutcha Kutchin in 1867 as "all well provided with necessities. They wear every variety of dress from mock uniforms or ordinary clothing imported by the Company, to moose and rein-deer clothing of every shape and style." The engravings in his book are very general, and despite his observations on diversity, he chose to dress most of his tiny figures in the pointed tunic which would no doubt have seemed more exotic to his British readers. William Dall, on the same expedition, also described and sketched Kutchin, but wearing a broader range of clothing. His field notes and resultant engravings (1870) show some Natives at Fort Yukon wearing the pointed tunic and moccasin trousers and others dressed in a modified English hunting shirt, European-style trousers, and over them, short leggings gathered at the knee.[8]

7. Lichen is self mordanting and can be used as a mordant for other natural dyes.

8. The tunics in Dall's engravings are actually based on a combination of Dall's field sketches of a Gens de Butte (Tanana) and specimens he collected from the Koyukon, but comparison with museum specimens and other descriptions show that they are basically accurate for the Kutchin. Duncan (1987) compares Dall field drawings and published engravings by Elliott in context with specimens collected by Dall and others.

FLORAL BEADWORK AND THE LOUCHEUX

Floral beadwork was first produced among Athapaskan speakers by those around Great Slave Lake, but the art quickly diffused north and west. The larger beads known at Fort McPherson came from Russia and were traded in from Kutchin living farther west, but seed beads and floral designs arrived there with the Hudson's Bay Company and women married to Hudson's Bay men. When Loucheux women married Hudson's Bay men, they worked alongside, sharing ideas and learning from other Company wives who had moved to the area with their husbands. Sarah Simon continued in talking about Kathryn Stuart:

My grandmother said, the first time when Hudson Bay people came down here, those are the first [white] people that came. Later on they brought so many things, and most of those people first they were the Scotch people and French, and Cree. These are the people that worked here first time.

There's Cree people that came. They brought their families, and the Cree women sew beads and put designs on. And these women [Fort McPherson women] got married to Hudson's Bay men. They picked it up from one another you see. They're all working together, so they start sewing.

Sarah thought that the first time Hudson's Bay people came to Fort McPherson was 1840 or even 1820, but that they did not have the little beads then. They first brought ammunition. She speculated that bead sewing first began at McPherson in the early 1860s

and that it was about 1862 when her grandmother learned to sew beads. As a Hudson's Bay wife, Kathryn Stuart also spent several years in other posts, Fort Smith, Fort Rae, Fort Simpson and Fort Good Hope, where her husband was assigned. No doubt she sewed beads and shared ideas with Hudson's Bay women there too.

The Hudson's Bay wives who came to Fort McPherson knowing how to do floral embroidery probably had been trained at mission schools run by the Grey Nuns. The order joined the Oblates to serve the central Subarctic in the mid nineteenth century, first at Lake Winnipeg in the 1840s, then in the area of Great Slave Lake and down the Mackenzie River during the 1860s and 70s. In the Lake Winnipeg area, girls were Cree, Ojibwa, or French Métis, a combination of one of these tribes and French ancestry. In the Great Slave Lake area girls at any given mission might be Slave, Chipewyan, Dogrib, or Yellowknife, or mixed blood, usually of Scots and one of these groups. Mixed blood families often spent most of the year in the post, because the European father encouraged education for his children. Orphan girls were also often raised at mission schools.

Bead and silk embroidery were important skills taught to girls in the schools. Celine Lafferty, a Slave-Métis woman now in her 80s and living at Fort Simpson, grew up at the Fort Providence mission during the first years of this century. She recalled that at the school the girls were taught sewing, including "fancy work" (embroidery), but that only those that were well behaved were allowed to embroider. Also, that at Fort Providence at that time

the nuns drew the designs for the girls. All the girls at a given school would learn to embroider and draw the same types of designs, and by the time they left school their embroidery style was well established.

The nuns who worked at the region's mission schools generally came from the Montreal Mother House where many of them had been educated together since girlhood. Therefore, we can expect their needlework training to have been the same. Although examples of designs definitely drawn by the nuns or pieces by them from the period are not yet identifiable, the unity of style in Native work resulting from their encouragement seems to bear out a unity in their training.

The Hudson's Bay Company and the Roman Catholic mission schools in the region of Great Slave Lake, then, were the major facilitators of diffusion of the art of bead embroidery to the Kutchin. It is clear that there was a good deal of contact between women about the lake and on down the Mackenzie River. Nuns in the region were transferred between missions and, as colleagues, kept in contact. Native women probably traveled even more, visiting back and forth with relatives and old school friends around the lake and to a lesser degree along the Mackenzie. Thus, similar training among nuns, and later their pupils, plus close intercourse within the region, reinforced style unity across it. It is not surprising that turn-of-the-century beadwork from Fort McPherson is closely related to that collected about Great Slave Lake.

It is far from clear how Cree influences and Athapaskan styles intermixed and evolved in the Great Slave Lake–Mackenzie River area. Interchange between Cree and Athapaskan Hudson's Bay wives such as that experienced by Kathryn Stuart, and between friends and neighbors in communities such as Fort Chipewyan where both Cree and Athapaskan lived, no doubt allowed intermixing of influences. Comparison of late nineteenth century work from Cree and Athapaskan communities does show style differences however.

Nor is it clear how to accurately apply the title Métis to the people involved. Because of the complexity over time of the changing situations and perceptions within individual lives and in communities, it is not possibile to determine with any sort of exactness who to call Métis, so community/tribal distinctions remain the most useful in speaking of the work. Kathryn Stuart spoke of the Hudson's Bay wives who came to Fort McPherson as Cree rather than Métis, and did not indicate their husbands' descent. Her granddaughter, Sarah Simon, clearly of mixed heritage, does not think of nor call herself Métis.

FLORAL EMBROIDERY AMONG THE WESTERN KUTCHIN

After their introduction into the area of Great Slave Lake, seed beads, the new idea of floral embroidery, and floral designs themselves diffused very rapidly north and westward. Unfortunately, information about the specifics of this movement across the Kutchin area is all too scarce. Floral work and seed beads were not present at Fort Yukon during the late 1840s when Alexander Murray was at the post, but by 1867 William Dall observed floral beading among a group of Kutcha Kutchin in the area.

> *The men wore the Hudson's Bay moccasins, leggings and fringed hunting shirts of buckskin . . . They had an abundance of the fine beadwork in which the French Canadians delight, and which those women who frequent the forts seem to excel in.* (Dall 1870: 101)

Unfortunately, Dall neither sketched nor collected any floral pieces (nor any pieces definitely Kutchin). Whymper, in his book relating the same travels (1869: 293), pictures a florally beaded fire bag but does not indicate its origin; the engraving is not sufficiently specific to allow stylistic identification. Museum specimens collected from the the Fort Yukon area in the late 1860s are of the old style costume. Dall and others seem to have preferred to collect what appeared to them to be unique, exotic, and old.

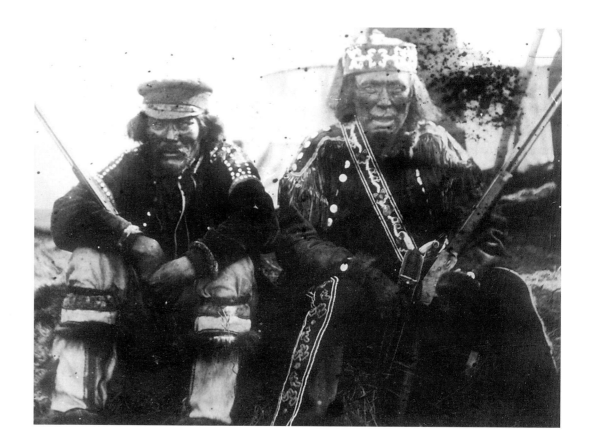

FIGURE 6 "Two unidentified Fort Yukon men in front of a tent," photograph taken 1877–1881 by E. W. Nelson near the mouth of the Yukon River. The figure on the right wears a beaded smoking cap, bandolier strap and knife sheath, leggings with side strips, and pointed moccasins. The button ornamented epaulets of his jacket are similar to those in Dall's earlier drawings. Elderly Kutchin thought that these men looked physically to be Kutchin, while those wearing English style hunting shirts in two other Nelson photos did not (see Fig. 23). Photograph courtesy National Anthropological Archives, Smithsonian Institution.

Floral work was probably rare, and since in Dall's mind it was associated with French Canadians to the east, to explain how it came to be worn by the Kutcha Kutchin may not have occurred to him. The earliest Kutchin floral examples were collected near the turn of the century.[9] At that time eastern Kutchin designs were similar to those from around Great Slave Lake and western Kutchin ones were clearly related but also showed some differences.

9. Although two pair of florally embroidered moccasins from 1860 have been called Kutchin, both attributions raise questions. VanStone (1981: 17, 23, 79) suggests that a pair of floral floss-embroidered moccasins in the Field Museum (14959) are Kutchin. They are a part of a small group of items from the collection of the Chicago industrialist Edward Ayer which may have been sent by the naturalist Robert Kennicott to his sister in the early 1860s. If indeed they are Kennicott pieces, they may instead have been collected when he traveled on the Mackenzie River where such work would have been more likely.

A pair of moccasins (RSM 563.1) embroidered in a simple floral design with folded porcupine quills edged in moosehair was received by the Royal Scottish Museum in 1860 from a Hudson's Bay employee, Andrew Flett, of Fort Simpson. Although they have been called Kutchin, the quillwork is typical of that from the Lake Winnipeg-area Métis of the time.

Kutchin floral beadwork belongs to the Great Slave Lake-Mackenzie River style region. Other groups included in the region are the Slave, Chipewyan, Dogrib, Yellowknife, Mountain, Hare, and Satudene. The beadwork designs of each of the groups are similar enough to warrant classification together. The region is very large geographically and although there is overall style unity across it, there are also subtle differences. Differences are most noticeable when one compares eastern and western Kutchin work. Turn-of-the-century Loucheux (Fort McPherson) work is more similar to that produced around Great Slave Lake, while beadwork from the western Kutchin shows a tendency toward simplification and regularization. Even in the twentieth century there is still a closer link between eastern Kutchin and Great Slave Lake work.

LOUCHEUX (EASTERN KUTCHIN) DESIGNS

All Kutchin beadwork is couched, following the contour of the form. Loucheux designs from the turn of the century, like those from communities on or near Great Slave Lake, are complex. There are many motifs in total as well as many different motifs (often eleven or more) in a given design. They are often organised asymmetrically and are packed densely so that little of the fabric ground shows. Individual motifs are usually a composite of several parts, constructed by a process of elaborating a central core element with several overlapping elements. Stems are usually dispersed in small segments, connecting the various motifs. There is normally a range

of scale within a design, as large and small motifs are combined. The rosette, rosebud, and berry are common motifs.

In Loucheux designs there are normally many different colors in the design as a whole as well as within each individual motif. Eleven or more colors per design are common and pinks, aquas, golds, greens and crystal are popular. Crystal is often used for hair stems. Within the several elements of a given motif, color typically changes in subtle gradation, every two bead rows. Metal accents, particularly at the points of petals, leaves, and tendrils, in the center of leaves, and at the center of the outer color layer of a petal, add another level of color intricacy. Black velvet is the preferred background.

A moss bag and shelf valance (Fig. 7) are a part of an important collection of examples from the lower Mackenzie, a group of pieces received by the National Museum of Canada in 1911 from H. A. Conroy. Conroy traveled with the government party negotiating Treaty 11. The exact provenience of the pieces was not recorded, however, a photo taken at Arctic Red River, an important post at the time, by a member of the boat crew on the trip shows a man wearing the jacket that is in the collection. Another photograph, taken at a post on the lower Mackenzie which the Hudson's Bay Archives identifies as possibly Arctic Red River, pictures a post manager and his wife in their living room decorated with shelf valances very similar to Figure 7 right, wall pockets, and pieced fur rugs of a type still made at Fort McPherson. (See Duncan 1988, Figs. 6.10, 6.25 for both photos.) In 1982 no one interviewed at

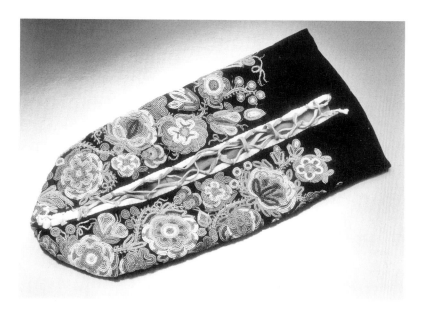

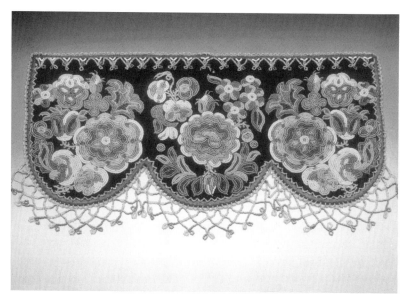

FIGURE 7 Left: Moss bag collected 1911 by H. A. Conroy on the lower Macken-zie River. Black velvet, seed and metal beads, muslin edging, hide thongs, red fabric lining. Not all western Kutchin women recognized the moss bag, a type which appears to have been far more common around Great Slave Lake and on the Mackenzie. National Museum of Man, Ottawa VI-I-5.

Right: Shelf valance collected by Conroy in 1911 on the lower Mackenzie. Black velvet, seed and metal beads. Splitting the color of a motif element vertically, a characteristic uncommon in the Great Slave Lake–Mackenzie River Region as a whole, occurs on several lower Mackenzie River examples which may well be by one maker. National Museum of Man, Ottawa VI-I-2. Both photographs courtesy National Museums of Canada.

Fort McPherson remembered the Conroy pieces or had any special comments about them.

WESTERN KUTCHIN DESIGNS

Western Kutchin designs from the turn of the century are slightly less complex than eastern ones. In any given design the total number of motifs is lower and there are fewer different motifs, usually more sparsely distributed. Designs are nearly always symmetrical. Motifs themselves are more stylized than farther east and are made up of fewer elements or parts. Where there are multi-element motifs, overlapping of elements is minimal, and those few motifs constructed by the process of elaborating a core element are simpler than their eastern counterparts. Stems are not random segments rather unpredictably located, but often form regularized, symmetrical networks, joining to become a single branching motif or a series of rhythmically repeated ones. Motifs within a design are usually of similar scale.

Round or dip petaled rosettes, and three petaled centerless rosettes, both which also appear on eastern Kutchin examples, are especially popular on western ones. So are a tightly scrolled tendril and a leaf made up of stacked parts (Fig. 8). Rosebuds are very rare.

A western Kutchin design uses fewer colors overall and within individual elements of motifs, fewer colors and color changes. Six

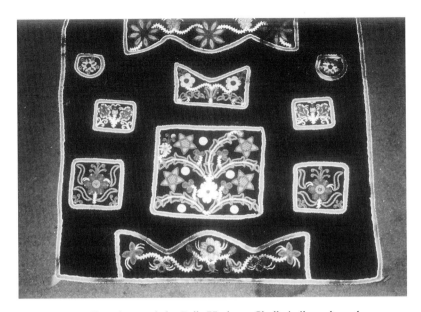

FIGURE 8 Wall pocket made by Belle Herbert, Chalkyitsik, early 20th century. Black velvet, seed beads, fabric lining. Western Kutchin wall pockets usually consist of a rectangular backing with several small attached pockets. Belle has used colored rather than metal beads for the accents at points and in the centers of outer petal layers.

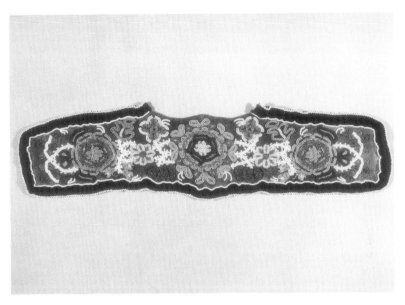

FIGURE 9 Jacket yoke for man's jacket, made by Eliza Ben Kassi, Eunice Carney's mother, Old Crow, 1920s. Caribou hide, seed and metal beads strung on sinew and couched with thread, black velvet piping. Pastel tones dominate on this yoke. Photograph by Paul Schwartz.

to ten colors is common. The pinks, aquas, golds, greens and crystal popular among the Loucheux maintain, but there is a decided preference for pastel combinations. There is also less variety in shades of a given color than farther east and white is preferred for hair stems. The more limited range of color may have been related to bead availability, as also seems to have been the case with metal beads. On western Kutchin examples metal beads are limited to petal and leaf tips and the center of the outer color layer of petals. Fort Yukon examples may substitute a red for a metal bead in such locations.

MOTIFS AND MOTIF NAMES

On older Kutchin beadwork, certain motifs are particularly common. A multi-petaled rosette, a three petaled centerless blossom, a sinuous leaf formed of stacked parts, berries either stemmed or stemless, and a split bell are particularly prominent. Kutchin women today have names for several of these motifs. The rosette with the metal accents in the center of the outer color layer of the petal is called *łaii kai* (Canadian) or *łaii kwai* (Alaskan)—dog paw. A three petaled centerless rosette is spoken of as *daagoo kai* (Canadian) or *dagoo kwai* (Alaskan)— ptarmigan foot. Both the tiny hair-like extensions on stems and a series of paired dashes are called *daatsoo aatlaa*—mice running, mice tracks, mouse jumping

31

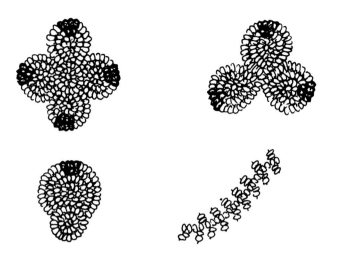

FIGURE 10 Named motifs: rosette with metal accents in the center of the outer color layer of petals—*łaii kai*, dog paw; three petaled centerless rosette with or without metal accents—*daagoo kai*, ptarmigan foot; lines (stems) with hair-like extensions—*daatsoo aatlaa*, mice running; two part bud—*dzan lin*, rat gland or beaver castor.

around. A bud-like motif formed of one circle showing only part way behind another is *dzan lin*—rat gland (referring to the swollen scent glands of the muskrat in season).[10]

In explanation of the term *łaii kwai* one woman referred to the paw mark that a dog will make on the porch when he comes in with wet or muddy feet. Sarah Malcolm, a Han woman interviewed in Fairbanks, also knew the name "dog paw" for the rosette with metal accents on the petals. Sarah drew a five petaled rosette, saying that the dark (metal) sections were the dog's nails. *Dagoo kwai* was explained as obvious since a ptarmigan has a three toed foot, and *daatsoo aatlaa* as similar to the marks made in the dirt by a running mouse. *Dzan lin* was mentioned less often and usually with laughter. The term proved difficult for women to translate; some suggested that it meant beaver castor.

10. Kutchin orthography courtesy of the Alaska Native Language Center, Fairbanks.

These several names appear to have been well established in the culture for a long while. Women deny that the designs tell some sort of story. One replied to repeated inquiry about the names with a gently exasperated, "Well, don't flowers have to have a name?"

In light of the history of the introduction of floral beadwork to the Kutchin (via Cree and Great Slave Lake Athapaskan women who had themselves been taught by nuns) this renaming takes on a new significance. It reflects the conceptual distance between the Kutchin beadworker and the European based embroidery patterns that were the source of the designs taught by the nuns. Whether Fort Good Hope women use these names awaits further research, but those living around Great Slave Lake had not heard of them and responded to them with amusement. Rosie Tsetso, a Slave woman at Fort Simpson woman recalled among her people having heard the bud form sometimes called a spider bump and the stem with projections pickerel guts, but such naming appeared to have been rare.

It is likely that the wider use of such names among the Kutchin is at least in part due to their having been less unencumbered by an expected, teacher-dictated vocabulary when the need arose for terms to use when talking about designs. It was rare for Kutchin women to go to Catholic mission schools since there were none located in the Kutchin area and their learning to bead was most apt to come through other Native women. That the names are common knowledge among the Kutchin suggests that the distance from the learning of the embroidery designs through direct teaching by nuns has been sufficient enough to have allowed the renaming.

It is significant that the motifs with names are the most common ones on earlier beadwork and that all refer to animals. The latter reflects the dependency on animals and the visual sensitivity to them that is still a part of the culture.

CHAPTER V ✳ *Beadworking in the Past and Today*

One objective of the research study was to determine the changes which have taken place over time in the Kutchin embroidery tradition and to document the state of beadworking today. It is clear that bead art is still very much alive. As with any art that *is* alive, there have been changes, in this case in items beaded, in media and in design, but the role that the art fills in the society has changed little. Beadwork remains the form in which a woman will make her most special gift, to a family member, a friend, the church or for a special community event.

Most Kutchin women who can still see do some beadwork. Some clearly get tremendous pleasure from the creativity; others bead more for something to do, especially when money is needed. Many women simply love to bead. Some are conservative in their range of production; others continually experiment and challenge themselves with new designs, colors, and forms. Some are more skilled than others. Some expressed frustration at what they considered their slowness, others at the impossibility of living long enough to do everything that they wanted to try.

TEACHING AND LEARNING

In earlier days a girl usually learned to bead as a child, but it was during her puberty seclusion, a period when she remained confined from males, observed certain taboos, and learned her duties as a woman, that she polished her skills at sewing and garment ornamentation. An older woman would instruct her at that time. She could make no male garments during her seclusion.

Today a girl will still learn from an experienced older woman but the teaching/learning situation is not so structured as formerly. Some of today's beadworkers learned to bead from their mothers; others learned by watching a friend or relative. Hannah Solomon of Fort Yukon, learned from her mother. So did Lily Pitka. Lily grew up in Stevens Village, but since her mother had family in Fort Yukon, moved there in 1926 at the age of 14 after her father died. She remembers her mother, Belle Luke, as a prolific sewer.

Gee, she used to sew lots. I used to sit and watch her, you know, and I didn't know I was picking it up. I think she just learned herself, and I learned from her. Sometimes I'd sit down and I begged her to make little doll shoes or slippers. Something, you know? Boy would she get mad at me. She hurried and made things, all that my father needed. So, finally, she gave me the needle. "Don't lose the needle now!" So she gave me the sinew, little thing, and I sit there and sew it. Pretty soon I get tired and go out and play. I make her real happy, you know, because I was doing everything.

Myra Kaye of Old Crow, born in 1890, learned both beading and silk embroidery by watching visiting Fort McPherson women sew. Arctic Village beadworker, Alice Peter, learned by observing others because her mother did not bead. So did Margaret John of Fort Yukon. Annie Fredson of Old Crow, was told how to bead by her husband, but preferred skin sewing over beading.

Minnie Peter of Fort Yukon, a generation younger than these women, was raised by her grandmother, whom she watched bead, but she did not become interested until later.

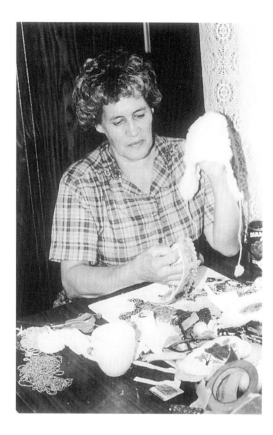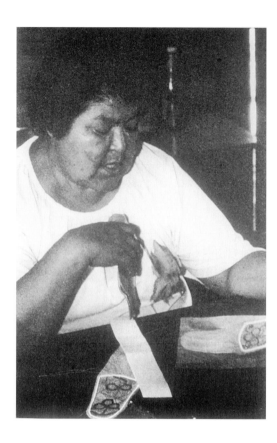

FIGURE 11 Left: Doris Ward of Fort Yukon. "It just makes you wish you could live forever so you could make different things!" Doris always has a variety of beading projects in progress.

Right: Minnie Peter of Fort Yukon. "I like to make something bright. If I want to sew, I like to make something pretty." The tongues she is making are for a pair of dance slippers. The outlined motifs will now be filled in, then the background will be beaded solidly in white.

We were taught when we were young. We got the general idea how to do it, but, like Doris was saying "We were young . . . we were young and foolish." Nobody cares then, you know?

She (my grandmother) tanned her moosehide, and I never paid any attention to her. She'd be doing everything by herself and she never say anything to me, to do this or that. Like cutting fish, I was standing there but I didn't want to do those things. I didn't know that they were part of our life, that we had to keep on doing this year after year. . . .

When Minnie later became interested in beadwork she learned in classes held at the school and taught by established beadworkers, among them Hannah Solomon and Annie James. Today she helps younger beadworkers who come to her.

Although most women seem to have learned to bead as children or young women, not all have continued. Some have chosen to sew skin and to arrange to purchase or barter what beadwork they need from others. A woman may acquire beaded parts from another, either as a gift or purchase, then put the item together

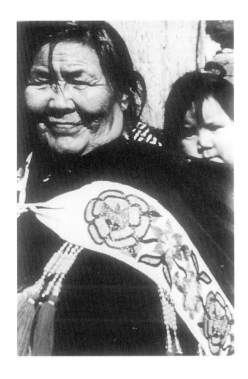

FIGURE 12 Left: Martha James of Arctic Village in a photo taken in the 1970s. She uses a baby belt to carry a grandchild on her back.

Right: Martha Benjamin and her grandson in a boat on the Porcupine River near Old Crow. On the living room wall in her home Martha displays the baby belt and hat that she made for the child. (See Fig. 53).

herself. If a name is associated with a piece, it is likely that of whoever put it together.

It appears that although a girl may be interested in beading as a teenager, other activities usually take precedence, and it is more apt to be during the years of raising a family that she establishes a beading routine. In Fort McPherson and Old Crow the popularity of baby belts encourages a woman to begin the major project of making one at the time that she starts a family. After that, there will continue to be family needs, especially for fancy moccasins for special occasions.

Sometimes a young boy learns to bead, helping his mother. A few men are known to bead today. Women mention this quietly but with admiration.

If beading is something a woman enjoys, she will likely continue it as long as she can see to do it. Many women commented that their eyes going bad had stopped their beading, or blamed deteriorated eyesight on having beaded in poor light over the years. The busiest time for beading is the period between Christmas and New Year's, despite its being the time of year with the least amount of daylight. There is a flurry of activity as women make moccasins and other beaded items for family members to wear to the New Year's dance. At such a time several may assist in completing the sewing. It is not unusual for more than one person to work on a piece. The Old Time Fiddling Festival sponsored by the Institute of Alaska Native Arts in Fairbanks each year is becoming an important occasion for the display of new beadwork.

According to Myra Kaye, now in her nineties, in earlier years when families were more nomadic, women took their beadwork with them and did it along the way. Now, those who like to bead, work on a project off and on whenever they have a chance to sit down. Some like to watch television as they bead. Women tend to bead alone at home rather than in groups, although one might take her work when visiting another if she wants help or ideas.

MATERIALS

Women everywhere commented on the tiny beads and lovely colors on older pieces, and on the amount of work that went into many of the most elaborate pieces. "They sewed a lot then. Now too many other things to do." They also admired metal beads, noting how difficult they are to get now. Sara Abel of Old Crow remembered first getting gold colored metal beads when she was 10 or 11 years old (about 1910); silver colored metal beads ("steel beads") had been available earlier. Women commented that silver beads had always been more readily available than gold ones. Women of Old Crow reported Fort Yukon to be their first source for thread and beads, both colored and silver metal ones.

On turn-of-the-century Loucheux beadwork the points of leaves, pointed petals and tendrils, and the centers of the outer color layer of petals are accented with metal beads. They are far sparser on western Kutchin pieces, and usually appear only at petal, leaf, and tendril points. When asked why the metal accents were used, women responded: "just for looks," "fancy," and "it looks nice."

Bead supply appears to have always been unpredictable in the Kutchin region. Hudson's Bay account books from the nineteenth century record the difficulties post factors had trying to keep up with changing tastes when it took several years for a bead order to reach England and the requested beads to be returned. Even today certain colors are sometimes hard to obtain. In 1981 and 1982 white beads were especially scarce in Fort Yukon and no one seemed to

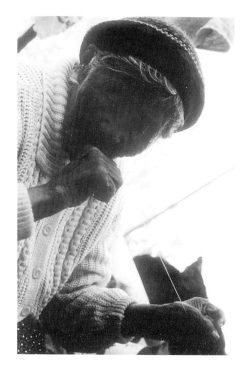

FIGURE 13 Myra Kaye (Big Myra), of Old Crow, making sinew. Although Myra had lost most of her eyesight, she liked still to twist sinew, something that can be done by feel. The sinew she twists is extremely fine and even. Myra remembered when thread first became available from Fort Yukon as a substitute for sinew.

know why. It is hard to determine to what degree women's preferences have influenced the beads available to them. At least one trader, Henry Carter, who ran a private trading company at Fort Yukon from the 1920s to the 40s, showed women bead cards and tried to order colors they wanted.

It is also very difficult to pin down exactly when a given type bead became available in a community. Some general trends can be cited, however. Fort Yukon work from the mid 1920s often includes a type of clear faceted color-cored bead on which the inner color has by now usually faded or rubbed away. What was once a sparkling rose is now a pale pink, greens have lost almost all of their color, and blues are now almost impossible to identify. Round beads with a soft silver-white pearly cast which women call

"pearl beads," and "satin beads," tubular beads of a similar cast, became available in the 1940s at Fort Yukon. Today both translucent and opaque beads are popular.

Certain color combinations are common for particular motifs. For instance, the large rose with flat, dipped petals and a heart-shaped center that has been popular in Fort Yukon and Old Crow since the early 1930s is almost always outlined in red and filled in with pink. Leaves of all kinds are green. At the turn of the century narrow leaves in green with a line of gold metal beads in the center were sometimes used, but a light green outline with a darker green filling was the most common. Today a dark outline with a lighter filling is also popular. For the last several decades gold-colored glass beads have been used in lieu of gold metal ones which are now very rare. If a woman today has some metal beads left from her mother or grandmother she occasionally uses them judiciously, usually in the old way, at a petal or leaf point.

Many Kutchin women have at some time embroidered with floss, but it is at Fort McPherson that floss embroidery has been the most popular and is still practiced today. In earlier years Sarah Simon of Fort McPherson embroidered a great deal with floss. She remembers flosswork as being faster than beadwork, and the fine embroidery silk and wool of former years as far superior to the cotton and synthetic fibres that are now available.

Women across the Kutchin area remember the dyed horsehair that was available in several colors from the Hudson's Bay Company and private traders earlier in the century. "They used to bring pretty horsehairs in different colors, very pretty." A bundle of several hairs wrapped tightly with hair or with embroidery floss was used as an edging around the tongue of the pointed toe moccasin.

Elderly western Kutchin women speak fondly of *niltłyaa*, a narrow wool military braid that came in several bright colors (red, blue, green, orange and yellow) and early in the century was sewn onto a black velvet ground. Women of Fort Yukon and Old Crow

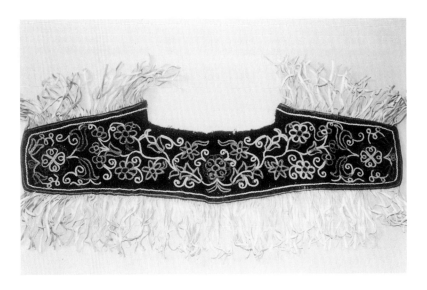

FIGURE 14 Yoke for a man's mooseskin jacket, made in the 1920s by Eliza Ben Kassi of Old Crow. *Niltłyaa*, (narrow military braid) on black velvet, caribou skin fringes. The yoke has been kept from light and the colors are bright, unfaded red, blue, green, orange and yellow.

sometimes used the braid to outline floral motifs similar to beaded ones, carefully tacking it down with small running stitches. Since *niltłyaa* is very prone to fading, on old pieces which have been subject to light, what was once royal blue is now grey, red has turned to a dirty peach, and bright green is now yellow.

Hide, black velvet or velveteen, and more recently, felt, are the grounds used by the Kutchin beadworker. Velvet has been popular since sometime late in the nineteenth century. Although red wool has been beaded on by neighboring upper Yukon groups for years, no one had heard of Kutchin women ever beading on red. Black wool, which is common in the neighboring upper Yukon area as well as among the Cree and to a lesser extent on Great Slave Lake, has rarely been used by the Kutchin.

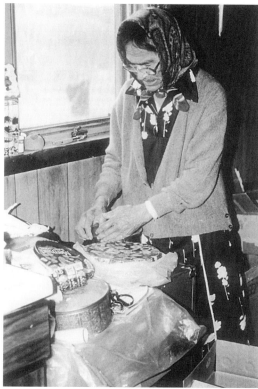

FIGURE 15 Left: Mary Firth, of Fort McPherson. In addition to bead embroidery, Mary also enjoys moosehair tufting, a craft especially popular today among Slave and Chipewyan women at Forts Providence and Resolution.

Right: Alice Peter of Arctic Village. A metal fruit cake tin is a common container for keeping beads and needles.

Nineteenth century tunics and leggings are made of caribou. Twentieth century hide work, particularly from recent years, is usually on moosehide. More porous than caribou, many women find it far easier to sew on with a needle. Although in Old Crow and Fort McPherson some women still tan hides, in Alaska, Native tanned hide of any type is very difficult to obtain today so commercially tanned hides are used. They are very expensive and women now sew far fewer large items such as jackets or gun cases because so much hide is required. In Alaska, several people complained that game laws make it too difficult to acquire hides even if one wants to do the tanning oneself.

About 1920, women at Fort Yukon began beading-in the background of some designs with white beads. Eunice Carney believes that Jenny Roberts may have been the first to solidly bead the background on moccasin fronts. "Filling in the moccasin fronts and sides solid with white beads after the floral design was sewed on was started about the year 1926. My guess would be that it came from Circle, Alaska. Jenny Roberts there was a very good sewer."

In the 1940s women began using white felt as a ground, since on a completed article with the background beaded solidly only a narrow edge showed and it actually looked much like bleached hide. Today, from Old Crow west, since hides are in short supply, felt is common for baby belts, moccasin tongues and small pouches, although elderly women talk about the days when black velvet was the only fabric available. Occasionally a woman will use light blue felt if she has no white, and will leave it to show as a background, but this is unusual. The thick felt of earlier years is now rare and women make do by combining 2 or 3 layers of thin felt. The stitches through the felt and paper backing are tight enough that the layers are often hard to discern.

DRAWING DESIGNS AND SEWING BEADS

When the background is of velvet, designs are still usually drawn using a stick or toothpick and flour-and-water paint, just as they were in the nineteenth century. Also as in the past, those on hide are drawn using red pencil or ink. Today's beadworkers caution against using ballpoint ink, since it cannot be removed if the design is changed during the course of the beading, nor do they recommend using black or blue ink. If changes should cause lines to show, red ones are not so noticeable as black or blue ones. The preference for drawing in red also relates to the use of red ochre when drawing out garment pieces on skin in earlier times.

Often two identical copies of a design are needed, as when a pair of moccasins or gloves is being made. If the ground is hide, the design is drawn on one of the pair then outlined in beads. The second of the pair is dampened and the two pieces are laid together and put under pressure. Martha Flitt sits on hers awhile while she sews on something else. Eunice Carney, who lives in Seattle, uses the heavy Seattle phone book. Transferring a design when it is to be beaded on felt is harder to do. Doris Ward sometimes draws the design on one piece, dampens the other, lays the two together, then applies pressure with a warm iron to transfer the design. She cautions that if the iron is too hot the color may run or the felt shrink.

Some women find drawing easy. Others do not. Some like to work freehand while others do not feel confident to do so. It is not uncommon for a woman known as a good drawer to draw for others on request. One woman, often asked to do so, mused:

Somedays I can draw real good; other days I can't draw. If somebody says "Draw some—draw this for me" I can't draw it. I kind of don't like drawing for people. They say draw a lot of stuff and sometimes I do. They just take it, say "Thank you," pay for it and not think about it. Give you fifty cents. In those days we didn't charge hardly anything for our work. And then later, people they say when you do good work and you make drawings for somebody else, they're taking your good work away from you.

Some women use patterns to draw around. Others do not. The woman who is a skilled freehand drawer is greatly admired, but the use of patterns is not looked down upon. Often a woman keeps her patterns in a metal box, perhaps a round fruitcake box, along with her beads and needles. Patterns are usually simple shapes of flowers or leaves cut out of paper. Rosettes are the most common. The inside lines of petals and the petal center may be drawn in on the pattern. Often a woman will cut the same motif in several different sizes. As she creates a new design she arranges and rearranges patterns for the basic motifs until she is satisfied, then draws around them and adds the smaller details freehand.

Some women own published embroidery patterns such as those sold by the Keepsake Transfer Company, but they usually use them only indirectly for ideas since they are designed for floss embroidery and the motifs are often too small to use with beads unless they are enlarged. In a Fairbanks shop one younger Fort Yukon beadworker purchased a group of beadwork patterns currently popular among Plains women. Published by the Celia Totus company, they include a slumped Indian on horseback, cabbage roses,

39

FIGURE 16 Left: Hannah Solomon of Fort Yukon and Fairbanks. Hannah's work has been well known for many years and is included in many museum and private collections.

Right: Sarah Knudson, Fort Yukon. Sarah has been particularly interested in the changing fashions in beadwork at Fort Yukon, and for the last few years has collected examples of each year's current fashion in barrettes, parka pulls, and such.

and a profile head of an Indian in a war bonnet. She has not used the patterns but found them interesting. Other Fort Yukon women have patterns that they exchanged in 1981 at a beading workshop sponsored in their community by the Institute of Alaska Native Arts. At that time Kutchin, Tanana, and Koyukon women came together to share knowledge and ideas. Those who do have patterns from elsewhere may experiment with them, but the bulk of their work is in established Kutchin styles.

Women will still occasionally draw designs that are "old style," ones using the motifs, the minimal stems, and the tendrils prominent on earlier work. One popular motif on turn-of-the-century western Kutchin designs is a curved leaf composed of pairs of stacked segments and a pointed central segment. There is no special name for the leaf. Minnie Peter believes it to be based on a real leaf.

A couple years ago we were out picking berries and we found this green leafy thing. It had all kinds of ways. It just went like this and like this and had leaves on it. It was just pretty. And they used to embroider those on the wall hangings.

A large, flat-petaled rose, usually with a heart-shaped center, has been popular in Fort Yukon and Old Crow since the 1920s. Today's designs tend to feature a few bold motifs against a white ground. Older work does not include designs which actually picture animals. Some women in Fort Yukon and Arctic Village have experimented with beading mountain goats, moose, fish and the like, but do not feel that they have always been successful. Hannah Solomon has interspersed butterflies with flowers several times on baby belts.

Pansies and the Alaska state flower, the forget-me-not, some-

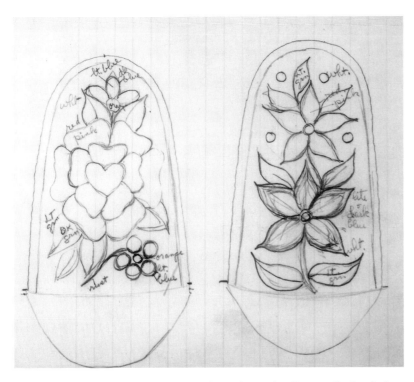

FIGURE 17 Moccasin tongue designs drawn by Eunice Carney. Similar designs are now used in both Fort Yukon and Old Crow. The rose with a heart center and large flat petals is a design that was first made in Fort Yukon in the late 1920s, then taken up in Old Crow a few years later.

Velvet requires fabric or paper backing to provide firmness. Paper is also often placed under hide to keep it from stretching. Felt may be backed with paper or fabric plus paper, for the same purpose.

Kutchin beadwork is couched. This two-strand technique requires that the beads be strung on one strand and tiny stitches be taken between beads using a second strand. Most women use a thin bead needle for both the stringing and couching of the beads. Although a couching stitch between every two beads is a sign of quality work, sometimes stitches are placed farther apart. Today thread is used for both strands. This is also the case for most old Kutchin floral pieces although on a few, sinew has been used for the stringing. The beadworker outlines the motif in beads then fills it in along the contour.

LINING AND FINISHING

Careful lining and finishing of edges is important to the Kutchin beadworker. Lining covers any stitches that might show on the back. The addition of piping to border a piece "looks nice." Bead edgings along the piping provide a neat finish and vary according to a woman's taste. Single-bead and picot (one bead up, one bead down) edgings are the most common. Today as in the past, very few women sign their work. Eunice Carney, who both signs and dates hers, encourages other beadworkers to do the same.

OLD CROW KNITTING

For some years the women of Old Crow have been known for a particular bead technique which they call "Old Crow knitting." It is used to make narrow strips that are then applied to moccasin cuffs or other items. Eunice Carney describes the technique as follows.

times appear on Kutchin beadwork but not nearly so often as do fantasy flowers. Both are far more popular, even characteristic, of beadwork of the neighboring Han. Forget-me-nots are easy to make and might be the first flower that a girl is taught. Hannah Solomon remembered making them "a long time ago" and doing some pansies in the 1940s. The altar cloth made at Arctic Village in 1957 (Fig. 69) features imaginatively colored pansies in the upper edging band.

Old Crow knitting design.

Thread movement

1.

2. knot turn

FIGURE 18 Diagram of "Old Crow knitting" technique. Drawn by Eunice Carney.

There is another way to make a solid beaded strip any width a person wants, a strip to sew down on hide as for moccasins cuffs, etc. This way is called "knitting" by the Old Crow women. There is a heart shaped design that is popular with them but difficult to do and is done only in Old Crow.

The one we will describe here will be the zigzag design.

First you use heavy duty polyester thread; use extra long double thread and a no. 10 short needle. (We use the extra long needles only for loom work.) To tie a knot, hold the threaded needle in your right hand with the ends of the thread lying under the needle. Wrap the long section of the thread around the needle about three times, hold the needle and pull to end of thread.

For a zigzag design the first row should have 3 beads of one color, then 3 of a second color, then 3 of the original color (9 beads in all). Then you pick up the middle bead of each color, using the same colors as you go along. To make it wider add more 3 bead groups. When you finish the zig and the zag, copy until you get the length you want.

If you make a mistake, you will know it. Calmly undo to there and try again. Good luck!

To tie on fresh thread, thread the needle and double the thread. Tie to end of the thread on the beadwork strip, using a square knot. Leave 3 inches of thread loose to later work thru beads and cut.

INDIVIDUAL PREFERENCES AND STYLES

Women are very aware of each others work, and of who they consider to be the best beadworkers in the community, both today and in the past. They are very astute in recognizing work from other communities and areas although they may have difficulty in articulating exactly what the differences are. Often individuals and communities have design and color preferences for which they are known. Women particularly appreciate fine quality work and designs that appeal to them personally, and are quick to comment on both. They refrain from criticizing more indifferent work.

Some women prefer to make certain objects or to use certain designs. Some use a limited range of colors; others try to create unusual combinations. Minnie Peter of Fort Yukon likes to make pointed petal flowers and roses with double rows of petals, and to use tan and peach. Margaret John, also of Fort Yukon, likes pastels and often uses violet beads.

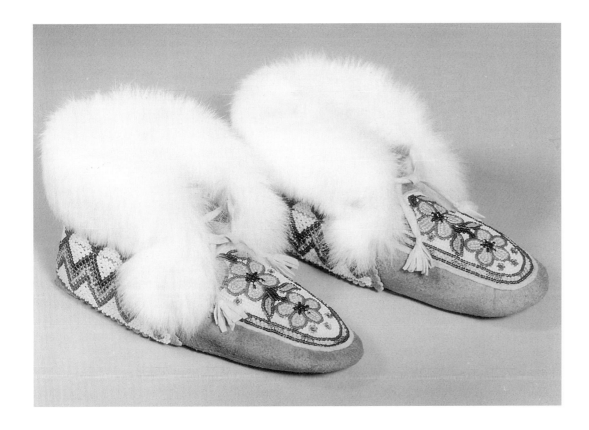

FIGURE 19 Woman's dance slippers with "Old Crow knitting" on the cuffs. Moose hide, seed beads on felt, white rabbit fur. Made in 1982 by Eunice Carney. Taylor Museum, Colorado Springs Fine Arts Center 1983.25. Photograph courtesy Taylor Museum, photograph by W. L. Bowers.

A long-time resident of Fort Yukon, Virginia Alexander, who was largely responsible for the establishment of the Dinji Zhuu Enjit Museum there and acted as its first director, shared her observations about beadworking in Fort Yukon. She has been a close observer of the approach each woman takes, of variations in attitudes, and in the beadwork itself. Her observations, which follow, have been somewhat condensed.

"A" will try anything on her beadwork and it is usually quite successful. And she'll get an idea not only for a design, but for different techniques … and different types of articles that are made.

She'll try pretty much anything and then if she likes it she'll do it again. But if she doesn't like it then she abandons it.

"B" is one of those people who's a perfectionist. She counts her beads. Every single petal on every flower has exactly the same number of beads. Her patterns are always balanced.

"C" now, is really a pretty strict traditionalist, and once you've seen several of "C's" pieces, you get so they're recognizable. "C" tends to use pastel colors quite a lot. She's also the one who generally makes things like Bible covers and if you want a Bible cover made she would be the person that you would probably be referred to, not necessarily but probably. But if you tell her what you want, it makes

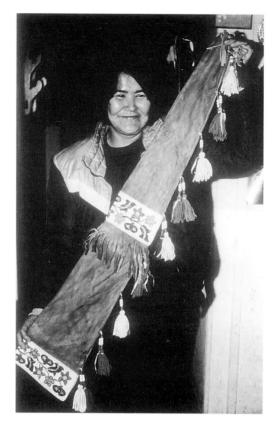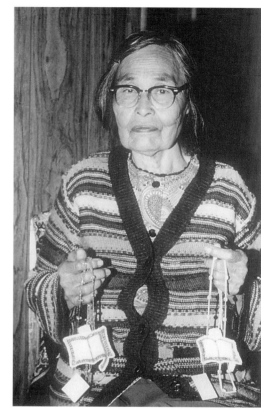

FIGURE 20 Left: Josephine Peter of Arctic Village. "I bead almost every day." Josephine had recently completed this gun case for her husband, using colors and motifs chosen by him. She also likes to make small items to sell through shops in Fairbanks.

Right: Martha Flitt of Fort Yukon. Martha has beaded for many years. Bible bookmarks which can also be worn around the neck are her own innovation.

her very nervous. I don't think she likes to do it that way. I think she would rather just make it and then if you like it then you can buy it, and if you don't like it you don't have to buy it.

Now "D" will come up with almost anything. You never know with "D." It's a surprise every time she opens up her little brown bag. You don't know what to expect. She does all sorts of different things. She's the only one I know who has ever made napkin rings. She doesn't like to do really large pieces like gun cases. Now one time she'll walk in with something that's done in the old style, you

know—with the lacy curvilinear design—and then the next. . . . Some of it (her things) you're going to look at it and say, "Where did this come from?" And nobody is going to know because it's not at all traditional. If you're really familiar with it you can see that she has on some of them repeated quillwork designs, but using different colors. Or that she's used the old style, but incorporated it into something else where the old style was not done. She's one of these who creates and plays with her ideas, and never is it exactly alike.

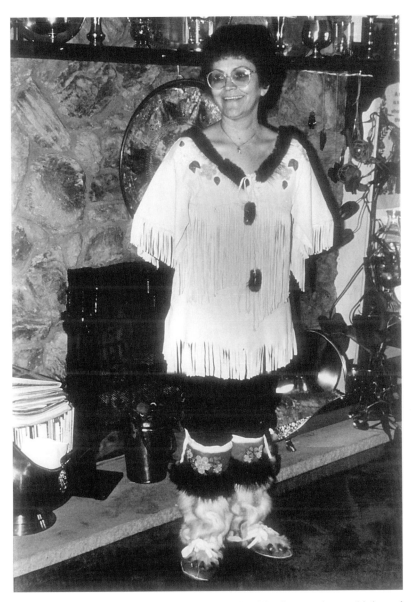

FIGURE 21 Delores Sloan, of Fort Yukon and Fairbanks, wearing mukluks and a blouse of tanned hide which she has beaded. Dee is one of the most prolific beadworkers and has made beaded pictures of presidents as well as a number of wide baby belts and other items.

SALE OF BEADWORK

In small communities beadwork is often sold via word of mouth. Particular items are often commissioned. There is enough traffic in and out of Fort Yukon and Arctic Village to allow women who bead a lot to deliver pieces to sell to shops in Fairbanks. In Fort Yukon the small museum has acted as an outlet for the sale of beadwork.

Virginia Alexander's observations from the period during which she directed the Fort Yukon museum profile the beadwork market in that community. According to her, the people of Fort Yukon provide the major market for beadwork made there. There is also a small tourist market since the community is a one day tour trip from Fairbanks. Fort Yukon is a popular tour destination of older people who wish to travel above the Arctic Circle and visit a bush community, but want a trip that is not too tiring or not so expensive as are tours to Nome or Kotzebue. Such visitors to Fort Yukon usually spend no more than ten dollars on beadwork. It is people of the local community who purchase higher priced items, particularly those costing $35 or more. Far more than the visitor, the Kutchin understand that good beadwork is not inexpensive. Several thousand dollars worth of beadwork may change hands during the November pre-Christmas sale coordinated by the museum.

CHAPTER VI ✳ *Traditions Old and New*

Some items that were beaded at the turn of the century have not been made for years, but elderly men and women remember them with pleasure. Pictures of a beaded man's hat, velvet tobacco bags, ornamented wall pockets, elaborate dog blankets, and pointed-toe moccasins brought to the surface warm memories. Some older traditions were remembered only vaguely or not all. In these cases responses helped to verify the geographic boundaries of earlier types. Other traditions have not been lost, and today's versions reflect the evolution of design and incorporation of new influences that have occurred over time. New traditions have also begun.

Repeatedly, people lamented the loss of old pieces, saying that things just had a way of being passed on or getting misplaced and disappearing.

Indians never used to stay one place. They like traveling, traveling place to place, and that way they never save anything from old times. And just (a) few people living always here, they don't keep anything like this. When anything is too old they give it to somebody that needs it, like that. Nobody keeps old things.

SARAH SIMON, FORT MCPHERSON

THE ENGLISH STYLE HUNTING SHIRT

The hunting shirt William Dall described in the 1860s being worn by prominent men at Fort Yukon was a fabric one with a half-oval bib and epaulets, both accented with pearl buttons and edged with fringe (Figs. 5, 22). Similar shirts made of hide, each with an elaborately beaded and fringed fabric bib and epaulets or back yoke, were collected on the upper Yukon in Tanana and Tutchone country in the late 1890s. The fabric on most of these is red wool. About 1880, while collecting among the Bering Sea Eskimo, E. W. Nelson photographed Athapaskan men who had come down to the mouth of the Yukon River to trade (Fig. 23), showing them wearing hunting shirts similar to those later collected. These have been thought to be Kutchin although Nelson does not identify them specifically as such. We hoped to clarify the distribution of the hunting shirt.

In 1982 the bibbed English style hunting shirt was unfamiliar to all the Kutchin men and all but one of the women who examined photographs of museum specimens and the photos taken by Nelson although memory was clear on many turn-of-the-century garments. No one had heard of Kutchin women ever having beaded on red fabric. Annie Fredson of Old Crow remembered that the trader Dan Cadzow had had a shirt a little similar, with a decorated front, but that it had "come from somewhere else." Several commented both that the Nelson photographs were not taken in Kutchin country and that the men in them did not look physically like Kutchin. It appears that by the time that the shirt was elaborately beaded, late in the century, the provenience was with the upper Yukon groups rather than the Kutchin.

JACKETS

Beaded jackets made of hide have long been prestige garments among the Kutchin and most other Athapaskan groups. By the

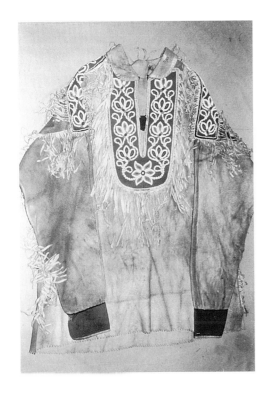

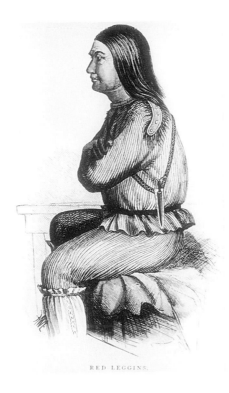

RED LEGGINS.

FIGURE 22 Left: English style hunting shirt, collected by H.M.W. Edmonds in Alaska, late 19th century. Hide, red wool, seed beads, fabric edging. Lowie Museum, Berkeley 2-6907.

Right: Engraving of Red Leggins, Chief of the Black River Kutchin, in Dall, *Alaska and its Resources*, 1870, opposite p. 110.

twentieth century the jacket had displaced the English style hunting shirt which in turn had displaced the pointed tunic before it. Today beaded jackets are called "chief's coats" by the Kutchin and other Alaskan groups. Old ones are still worn with pride, but few new jackets are made since they require so much hide and hide is scarce and expensive. The beading on turn-of-the-century Kutchin jackets is usually on a black velvet ground, whereas those from other groups such as the Tanana typically use a red or navy/black wool ground.

THE "TIN" HAT

In museum collections there are several round velvet hats beaded with metal beads and sporting a silk tassel which were collected on the lower Mackenzie or the Yukon River. Each is made of black velvet laid over a birch bark cylinder to make it stiff. The sides are beaded as are sometimes the top and/or the medallion from which the tassel hangs. The hats are almost identical in cut to men's smoking hat patterns published in Victorian magazines and were surely influenced by them. Although nearly monochromatic, the motifs are typical of the Kutchin, even to the placement of accents in a different color (a different metal here) at the points of motifs.

People as far west as Arctic Village, particularly men, remembered this type hat. In both Fort McPherson and Arctic Village the name "tin hat" was mentioned, referring to its being embroidered solely with metal beads. Chief Christian of Christian Village, a prominent chief whose impressive beaded garments and dog

47

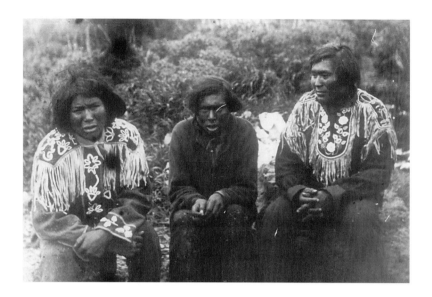

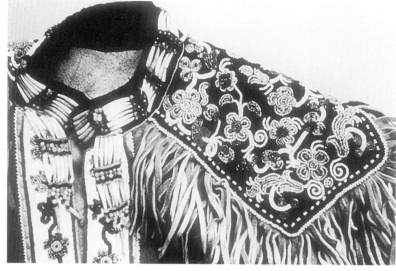

FIGURE 23 Men sitting outdoors. Photo taken by E. W. Nelson, 1877–1881 near the mouth of the Yukon, and identified by him as men who had come down the Yukon River to trade. Elderly Kutchin examining this photograph felt that both garments and physical characteristics showed that these were not Kutchin men. They were sympathetic toward "that poor guy in the middle—he doesn't have anyone to make fancy clothes for him." Photograph courtesy National Anthropological Archives, Smithsonian Institution.

FIGURE 24 Yoke and front placket of a jacket made by Belle Luke in Fort Yukon in 1926 for her husband Jacob Luke. Belle made the jacket and her daughter, Lily (now Lily Pitka) did the bead embroidery. Lily was 14 years old at the time. The beads came from Fort Yukon and include many translucent color-cored ones where the inner color has faded badly. The small same-scale motifs distributed without a strongly ordered stem pattern is unusual for work of the period. University of Alaska Museum, Fairbanks 773. Photograph courtesy University of Alaska Museum.

blankets were often recalled, wore such a hat. Sarah Simon of Fort McPherson suggested that this is a type hat that her grandmother referred to when she spoke of one worn first by Scots people who came to McPherson with the Hudson's Bay Company. Sarah thought that her grandmother had made such hats.

Some people believed the hat to be a prestige item: "Wealthy people wear that hat, but not the poor people." (Sarah Simon, Fort McPherson.) Others remembered it as more common: "At my time I see a lot of them. They used to make this kind with boards. You know, they bend it around like this. And then they put velvet or something on it." (Moses Tizya, Old Crow.) Moses remembered silk embroidered hats as well as beaded ones.

Isaac Tritt, Sr. of Arctic Village recalled his father's hat which had beads only on the medallion. The hat had beaver along the side, a velvet top, marten tail trim and a velvet lining. The "string" (tassel) hung from a small medallion with a beaded rosette.

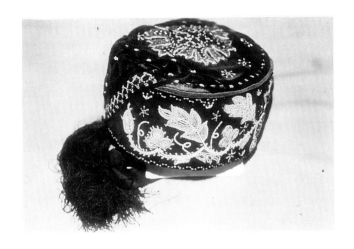

FIGURE 25 Man's hat, Loucheux, ca. 1902. Black velvet with silver and gold metal beads and silk tassel. Stone Collection, American Museum of Natural History 50/3900.

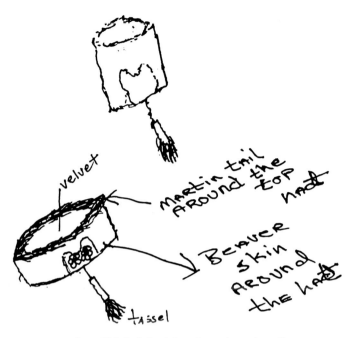

FIGURE 27 Isaac Tritt's father's hat. Isaac drew the taller version, then Bertha Ross the shorter one, in order to achieve what he considered more correct proportion.

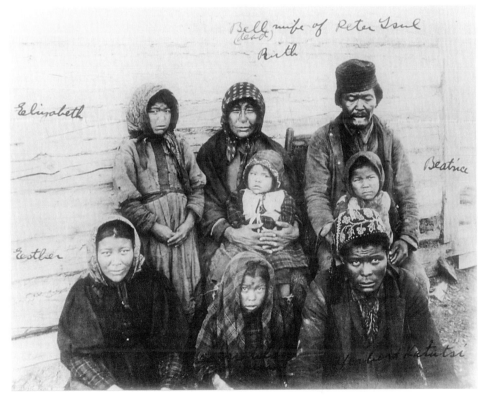

FIGURE 26 Family group, probably at Fort McPherson, early 20th century. No one recalled Herbert Katatsi who wears the smoking hat. Moses Tizya, of Old Crow remembered Peter Ross as also being called Peter Tsul (small). Tsul was an interpreter for Anglican Bishop Stringer. Tizya suggested that others in the photograph belonged to the Albert Ross family. Several people commented that the handling of the corners on the wooden building identified it as having been built by the Hudson's Bay Company. Photograph courtesy Anglican Archives, Toronto.

49

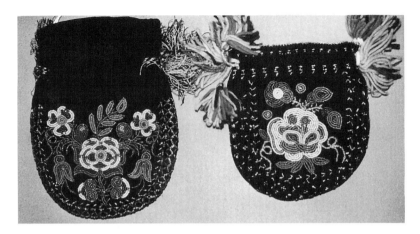

FIGURE 28 Velvet tobacco pouches with floral patterning in colored beads and edging in metal beads. Left: Great Slave Lake. Received 1911. National Museum of Man, Ottawa VI-E-30.
 Right: Collected 1913 by J. A. Mason at Fort Rae. National Museum of Man, Ottawa VI-E-37.

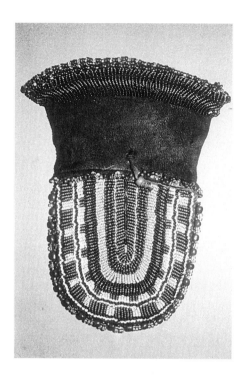

FIGURE 29 Tobacco pouch, Kutchin. Dark dyed hide, beads. Museum of the American Indian, Heye Foundation 19/687.

TOBACCO POUCHES

Soft, oval bottomed tobacco pouches made of dark, usually black, velvet with a drawstring ending in tassels of multicolored silk floss, were collected near the turn of the century on Great Slave Lake and the Mackenzie River. Such bags are beaded or floss embroidered with colored flowers on both sides. Often patterns of repeated V's or X's (in metal beads on beaded bags, in thread on floss embroidered ones) follow the side seams and the sewing lines of the drawstring channel.

Several men and women remembered such pouches, and identified them as women's tobacco pouches. Lily Pitka, of Fort Yukon had made similar ones.

A few examples of another small pouch identified as Mackenzie

River or Kutchin occur in museum collections. This bag is oval bottomed, made of hide, and beaded solidly along the lower two-thirds in concentric U forms in arrangements of blue, red, white, and sometimes pink. The beads are applied using lazy stitch rather than couching.

Few people recognized the pouch or that it was a bag at all. (The photograph had been greatly enlarged and the pouch was sometimes confused with a mitten.) Alice Peter of Arctic Village identified the type as a summer time tobacco pouch, one used by old people, and stuck in the belt. An old man called Strong Hat had had one. She related the design to old porcupine quill designs, and suggested that when people ran out of tobacco they could smell and suck the hide.

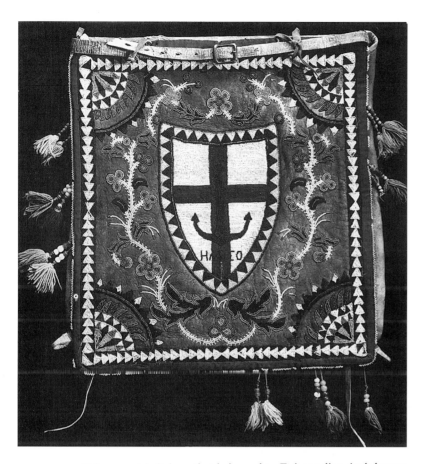

FIGURE 30 Toboggan (sled) bag, that belonged to Episcopalian Archdeacon Hudson Stuck. The bag appears in several old photographs of Stuck, one published in his book, *10,000 Miles With a Dog Sled*. (New York: Scribner, 1916.) University of Alaska Museum, Fairbanks 69.54.10. Photograph courtesy University of Alaska Museum.

THE TOBOGGAN BAG

A toboggan bag that was made for the Episcopalian Archdeacon, Hudson Stuck, probably sometime early in the 20th century was among our photos. The bag, now in the University of Alaska Museum, has been thought to have come from Fort Yukon or nearby. Kutchin people remembered Stuck and his companion, Walter Harper, well, and admired the bag, but no one remembered it. Several people suggested that it looked as if it were made "somewhere else," "maybe down river." (In interviews, Kutchin used the term "down river" rather broadly to mean somewhere else, down the Yukon, the Tanana, or the Porcupine rivers.) Kutchin women spoke vaguely about having occasionally made toboggan bags, but the form seems to have been less common than among neighboring Upper Yukon Athapaskan groups.

SHOT POUCHES

Although there are a number of Athapaskan shot pouches (also called shell bags, ammunition bags or fire bags) in museum collections, they are seldom attributed to the Kutchin. One of the photos taken about 1880 by E. W. Nelson of a Fort Yukon man holding a rifle, shows him wearing a florally beaded shot pouch around his neck. Kutchin, both men and women, recognized a photo of an Upper Yukon shot pouch as such but commented that the beadwork did not look Kutchin. As with the toboggan bag, they knew the type but were vague when discussing it. Several older women had made ammunition bags but were not specific about the decoration.

Arthur James of Fort Yukon, said that such a bag was used to keep gun powder dry or to keep tobacco in. "When we were small, people were all decorated. They would wear the pouch all the time." Isaac Tritt, Sr. of Arctic Village maintained that the bag was only for "gun stuff," that bullets and needs for firemaking were carried in it, but that tobacco was not.

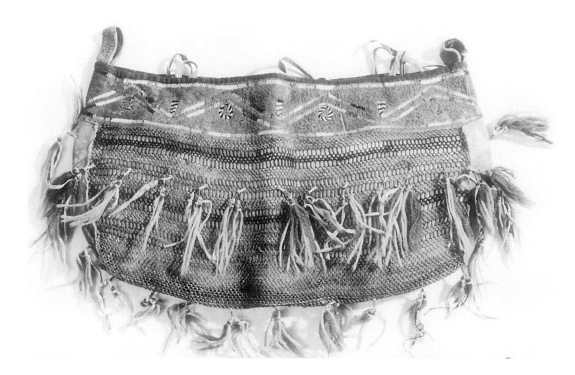

FIGURE 31 Babiche bag, Hare. Hide, velvet, folded porcupine quills, cotton fabric edging, wool yarn tassels, natural pigments. Collected before 1905 by Father Cloutier. Manitoba Museum of Man and Nature H.4.33.2. Photograph courtesy Manitoba Museum of Man and Nature.

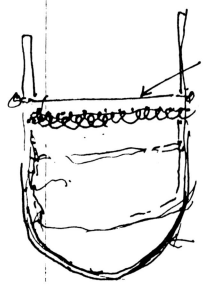

FIGURE 32 Drawing of the frame for making a babiche bag, by Elizabeth Mackenzie, Dogrib, of Fort Rae. Babiche is made of raw caribou hide cleaned of all the hair and gristle and, while wet, cut into strips lengthwise. The netting progresses downward from an upper hide strip stretched between either end of a curved sapling frame.

BABICHE BAGS

Another item found in old collections of Great Slave Lake–Mackenzie River embroidery is a wide, open bag formed of a folded rectangle of loosely looped babiche, attached to side strips and a wide strip ornamented across the upper front. Colored horizontal stripes are subtly incorporated in the looping and yarn tassels are attached in rows across the front. This type of babiche bag is still made occasionally by women in the Great Slave Lake area.

Although several such babiche bags in museum collections are identified as Kutchin, this type was not familiar to any Kutchin person who examined the pictures. That three bags were included in the photograph, laid one above the other and overlapping, proved to be confusing to some, and may have influenced responses. Alice Peter, of Arctic Village, recognized the bag as a

game bag where grass was packed in, then game or fish were carried. Unfortunately, we did not have a photograph with us of the stiffer, tubular babiche bag used by some other Athapaskan groups in British Columbia and Alaska. The Kutchin seem to have used babiche mostly for snowshoes.

DOG BLANKETS

During the second half of the nineteenth century the Cree, the Athapaskans of Great Slave Lake and the Mackenzie River, and to a lesser extent the eastern Kutchin, used ornamented dog blankets (tapies) on special occasions. Older western Kutchin remembered that early in the century an ornamented team occasionally visited but that the event was rare. A team with fancy dog blankets belonged to a "big man," a wealthy man such as the admired Chief Christian who lived at Christian Village near Arctic Village. Christian got some of his beadwork in Canada.

Dog blankets are of a conventional form, rectangular with rounded corners, and edged with yarn fringe in blocks of various colors. The blanket is made from velvet (usually black) and beaded, or from white wool and embroidered with yarn or floss. A fabric strip bisects it lengthwise and usually sports one or more rows of sleigh bells. The blanket is backed with canvas for support.

Elderly Kutchin sparkled as they recalled the excitement of an ornamented dog team rushing jubilantly into a village. Eunice Carney remembered Chief Christian coming into Fort Yukon in 1926 with his decorated dogs "so pretty and those bells just ringin, ringin, ringin." Dan Cadzow, proprietor of the Rampart House post in the Yukon, just inside the Canada–Alaska border, also had a set of beaded blankets.

Myra Kaye of Old Crow once made a set of four dog blankets with silk embroidered flowers and ribbon around the edge. Isaac Tritt, Sr. of Arctic Village recalled that his father, Albert Tritt, had had a set of six blankets which Isaac's mother beaded about 1910 or 1911. As was typical, Albert's dogs also wore a standing iron, a

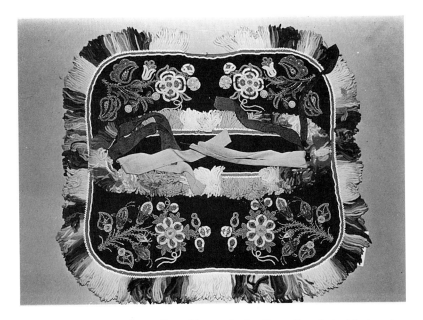

FIGURE 33 Dog blanket, collected in 1912 in the Great Slave Lake-Mackenzie River area. Black velvet ground, seed and metal beads, military braid edging, yarn fringes. McCord Museum ME966X111.1.

stiff round padded collar that fit around the neck and supported a projecting rod, "a horn." A multicolored pompom was attached to the top of the horn, along with bells and "different kinds of ribbons, long ones," and "weasel tail among the ribbons."

Isaac's father used his blankets all of the time in the winter when it was at least 30 below zero, but took them off when the weather changed because in springtime it was too hot. Not all dog runners did this, however. Louis Mercredi, now in his 90s, a Chipewyan-Métis living at Fort Smith, ran dogs for many years for the Hudson's Bay Company. He used fancy blankets only occasionally, putting them on a few miles out before he entered a community. Fancy or plain, blankets provided his dogs warmth during the coldest weather. Whichever blankets were used, he removed and

53

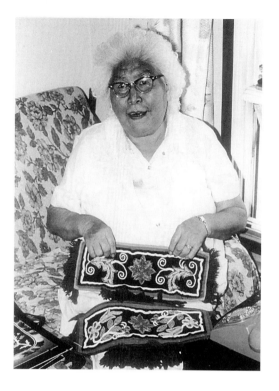

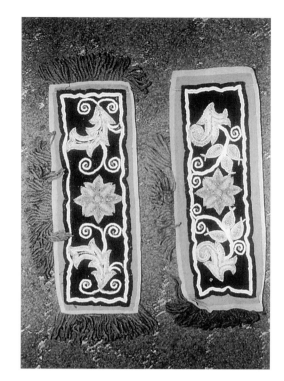

FIGURE 34 Lily Pitka, earlier of Stevens Village and Fort Yukon, photographed in Fairbanks with two dog blankets from the set she made about 1926. Her mother, Belle Luke, drew the designs for Lily, then a teenager, to bead. Lily was not familiar with the larger type dog blankets. Her narrow blankets, like the larger ones, lay over the back of the dog, perpendicular to the spine.

dried them by the fire each night so that the dogs would not get sick from the dampness caused by perspiration. Louis liked the color provided by the standing iron ribbons blowing in the wind, and also used them to help him keep his direction when crossing Great Slave Lake in fog.

A SPECIAL WOMAN'S DRESS

References are ambiguous but seem to indicate that the western edge of distribution for an applique tunic used on Great Slave Lake, particularly by the Slave, was with the eastern Kutchin, and that it was worn among them later than elsewhere. Petitot (1876, Mason translation) describes tunics decorated with beads and with metallic trinkets, tufts of wool and fringes worn by the Loucheux (the eastern Kutchin).

The earliest eastern appliqué tunics are made of tanned hide, and have a straight hem, straight shoulder seams and set-in sleeves, and a large cape collar, cut round or square. The collars are ornamented lavishly with bands of applique of red and blue/black wool broadcloth edged with white beads, thin fringes partially quill wrapped, wool yarn tassels, and often metal tinklers. On the round collars, there are usually additional bands embroidered with seed beads falling parallel to the collar edge, on shoulder epaulets, and sometimes on a connecting strip that would be worn at the front. One elderly Slave woman indicated that the the dress was used at

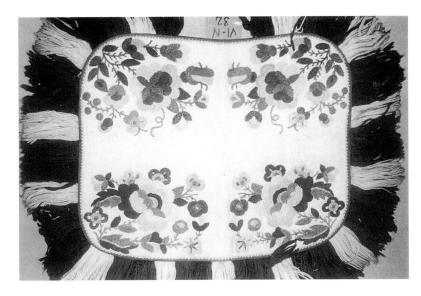

FIGURE 35 Yarn embroidered dog blanket, Slave, Fort Providence. White duffle ground with wool yarn chain-stitch embroidery, military braid edging, yarn fringes. Yarn embroidered blankets are less frequent in museums than beaded ones although elderly Athapaskan people suggest that they were more common. National Museum of Man, Ottawa VI-N-32.

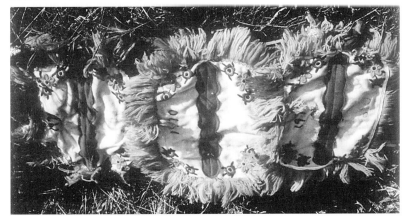

FIGURE 36 Yarn embroidered dog blankets made in 1970 for Stephen Frost of Old Crow. Wool yarn satin-stitch embroidery on white duffle. Frost used these during competitive dog racing.

a girl's "coming out" when she was presented as marriageable. Although most complete applique tunics were collected from the Slave, at least two collars have been suggested to be Kutchin (Fig. 38).[11]

In 1982 elderly Kutchin did not remember garments exactly like the Slave applique tunic. Sarah Simon thought that something similar had been used at Fort McPherson but that it was also somehow different. The photographs reminded western Kutchin women of a velvet dress with a wide beaded collar, cuffs and belt, that Mary Johnson of Fort Yukon made for her daughter, Lena, in the 1930s. It was suggested that the dress, like many other prized possessions, had probably been lost in the Fort Yukon flood of 1949. This collared dress (Fig. 39) appears to have been a more recent version of the earlier garments.

Short fabric leggings beaded along the bottom were often worn with the applique tunic in the area of Great Slave Lake and several have been collected from groups there, but the spotty information suggests that among the Kutchin simpler versions were more common. Dall's 1870 engraving (Fig. 5) shows men wearing a short unornamented fabric legging tied at the knee.

Some older Kutchin generally remembered fabric leggings. Myra Moses of Old Crow knew of women having worn short fabric leggings. Martha James' mother, who came from Canada, wore short leggings with garters. Moses Tizya of Old Crow remembered men's long fabric leggings with strips of beadwork up the side, similar to those worn in one of the Nelson photographs (Fig. 6). Annie Fredson had learned to make long leggings some years previous while in the hospital in Edmonton.

11. Some variation on an applique woman's dress seems to have been present in most of the Great Slave Lake–Mackenzie River Region late in the nineteenth century. In the early years of the twentieth century the Dogrib made a more fitted applique dress without a beaded collar.

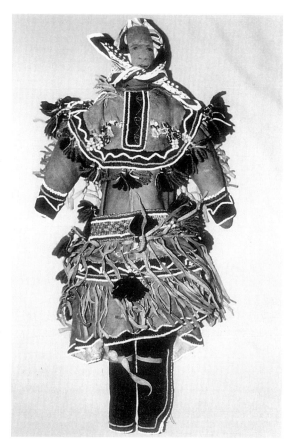
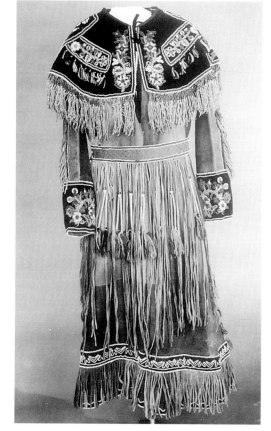

FIGURE 37 Left: Doll wearing applique dress, Hay River, Slave, early 20th century. Hide, wool fabric, seed and metal beads, wool yarn, cotton fabric scarf. Rusler Collection, Glenbow Alberta Institute AC 328.

Right: Tunic with separate collar and belt. Hide, wool, velvet, quills, yarn. From the checked belt hang fringes with wooden tubes and yarn tassels attached. The floral work on the collar and wide cuffs is similar to that on pieces from the lower Mackenzie. The costume was collected before the 1920s at Fort Chipewyan. Alberta Provincial Museum H73.55.1. Photograph courtesy Alberta Provincial Museum.

56

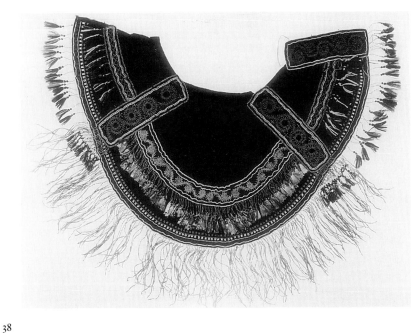

38

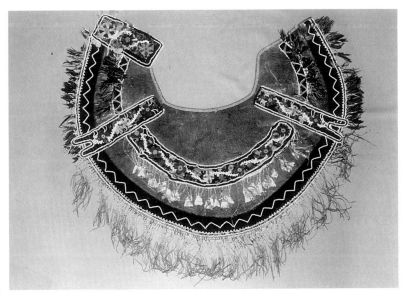

38

FIGURE 38 Collars, probably Mackenzie River Kutchin. Velvet and wool fabrics, seed beads, hide, quills, metal tinklers, wool yarn.

Upper: Lower Fort Garry 61–214. The geometric pattern along the edge is called "mice running" by today's beadworkers. The spirals also appear along the lower edge of short fabric women's leggings collected around Great Slave Lake at the turn of the century.

Lower: Lower Fort Garry 4437. The dominant white stems and small motifs are typical of other Mackenzie River Kutchin pieces.

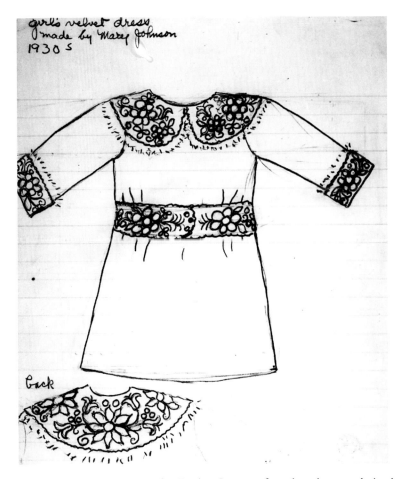

FIGURE 39 Drawing, 1984, by Eunice Carney, of a velvet dress made in the 1930s by Mary Johnson of Fort Yukon for her daughter.

Kutchin women, like those living around Great Slave Lake, have for many generations carried their babies using broad ornamented carrying straps they call baby belts. In early years a birch bark seat that could be strapped to the back was also used. The Kutchin's neighbors, the Koyukon, Tanana, and Nabesna, used baby belts only occasionally if at all, but the Kutchin still make and use them today.

The baby carrying strap was traditionally worn looped over the shoulders and tied at the neck. A young child caught up in a shawl could ride facing the direction in which the mother faced, well supported, looking or sleeping. The mother's hands were free, yet the child was close and its needs could be attended to easily. Sometimes the job of "packing the baby" fell to a teenager. This may explain the very young girls pictured in several old photographs.

Bird quill belts with long fringes decorated with beads, yarn, and sometimes tin tinklers or bird bones and sometimes associated with the applique tunic just discussed, were probably baby straps. Several long belts of woven quills in museum collections were also baby straps. One such belt, made in the Liard (Slave) area, and used years ago by Mary Firth of Fort McPherson, now belongs to the Alberta Provincial Museum (cat. no. H65.235.42). Ellen Abel, of Fort McPherson, remembered having strung bones on a baby belt.

Baby belts range from about 3 to 5 feet in length and are normally 4½ to 5 inches wide. Those from Great Slave Lake groups usually have rounded ends with hide ties, and are beaded on black velvet bound with a fabric edging. Kutchin belts are most often square ended with ties or a button and hole arrangement of hide attached at the ends. Turn-of-the-century Kutchin belts are usually beaded florally on a black velvet ground attached to canvas and backed with hide. Since sometime in the 1920s most from Fort Yukon have been solidly beaded, usually with a white background. Since the 1940s solid beading there has been done on felt rather than hide.

58

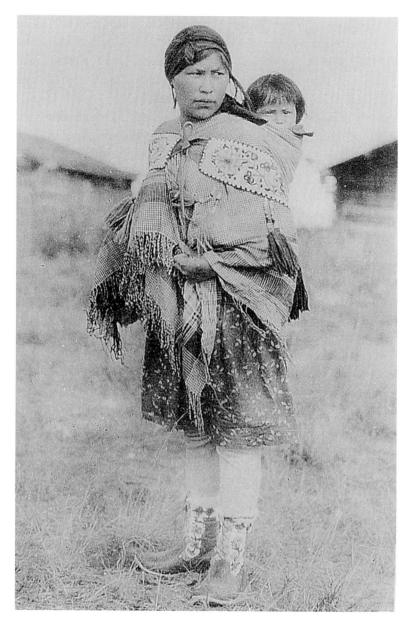

FIGURE 40 Fort Yukon woman with baby. From a postcard.

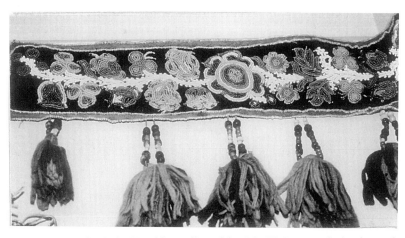

FIGURE 41 Baby belt, Kutchin, collected by M. W. Pope early in the 20th century. Pope's collection is thought to be from the Yukon River, therefore most likely Fort Yukon, but this belt may have been made farther east. The beadwork is more characteristic of early 20th-century work from the lower Mackenzie River than of Fort Yukon work of the time. Museum of the American Indian, Heye Foundation 16/1651.

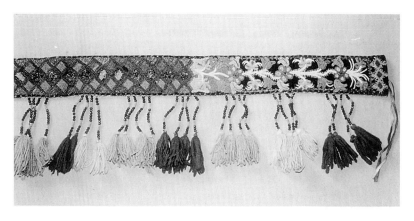

FIGURE 42 Unusual in its combination of floral and geometric patterning, this belt belonged for many years to Gertrude Curtis, a school teacher at Fort Yukon and is now in a private collection. Several women in Fort Yukon and Old Crow remembered that Mary Johnson beaded the floral ends and Julia Loola did the geometric section, the two working together on the belt one winter in the 1920s. Abbie Peter thought that Julia began the belt and Mary agreed to finish it.

Some women reinforce with both paper and canvas backing. "That way, when it stretches, it doesn't tear the beads and the thread that much." (Minnie Peter, Fort Yukon.) Belts beaded on felt, like other beadwork, are carefully lined when finished so that stitches do not show.

A few Kutchin baby belts were beaded solidly in a pattern of horizontal rows of connected diamonds rather than with flowers. Sara Abel and Martha Kendi, both of Old Crow, once made this type; Sara's belt was remembered and mentioned by women of Fort Yukon who knew it. Older Kutchin people commented that the diamond design was based on old quill designs, but no one knew how to do the quill weaving still practiced in the Great Slave Lake area and at one time by the Loucheux to produce such belts. (See the collection of the Haffenreffer Museum of Anthropology,

Brown University, for several woven quill belts collected from the Kutchin).

The general observations about eastern and western Kutchin style differences previously discussed hold true on baby straps from the turn of the century. In addition, the solid white background, which began about 1920 at Fort Yukon, was soon taken up by some beadworkers at Old Crow. Several older Fort Yukon belts with white beaded background, divide the space horizontally into three parts, a broad central band with a centrally focused foliate design, and a narrow band on either side with a repeated pattern of rosettes alternating with S-curved stems. The similarity of these outer bands to the vertical decorative bands on the altar cloth beaded at Fort Yukon at the end of World War I suggests that they were inspired by it and date to the early 1920s. The altar

59

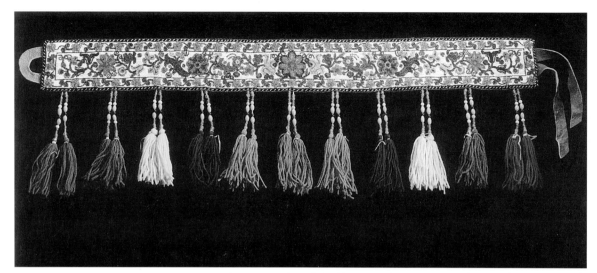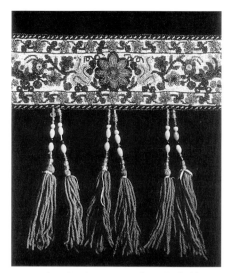

FIGURE 43 Baby belt, Fort Yukon, early 20th century. The solid white ground, banded arrangement, and intricate lacy floral work of ordered same-scale motifs is characteristic of Fort Yukon work early in the century. This belt is wider and more elaborate than most and includes the now faded color-cored beads in deep pink and green that were popular at Fort Yukon in the 1920s. The spiraled brass beads in the rosette centers are very rare. University of Alaska Museum, Fairbanks 1042. Photograph courtesy University of Alaska Museum.

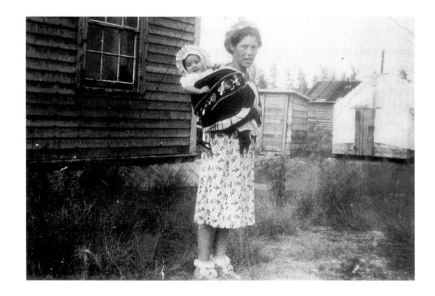

FIGURE 44 Eva Koe and child, Inuvik, 1930s. Photograph courtesy of Dinji Zhuu Injit Museum, Fort Yukon.

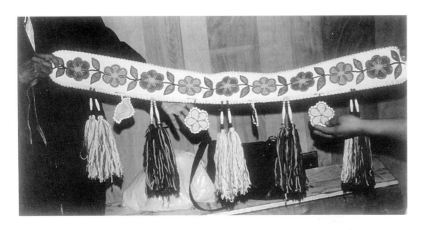

FIGURE 45 Baby belt made by Nancy Flitt of Old Crow, 1982. The hanging medallions are her own innovation.

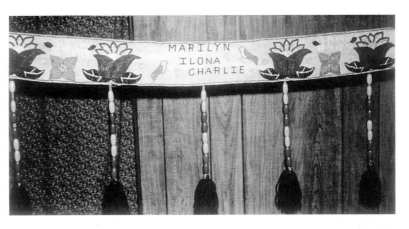

FIGURE 46 Belt made ca. 1982 by young beadworker, Agnes Charlie, of Old Crow.

cloth patterning, based on that of traditional hangings, was introduced by Mrs. Burke, the wife of the community's Episcopal minister.

Baby straps are still made and used by Kutchin women, particularly those in Old Crow and Fort McPherson. Although older Fort Yukon and Arctic Village women had all made them, there were none in evidence in use in those communities. A Fort Yukon woman commented that they are now brought out only occasionally, to show them off. In Old Crow, several younger beadworkers were pleased to show belts they were working on or had finished for their children. In Fort McPherson belts were both displayed on walls and used. A belt is considered to belong to the baby for whom it was made. Contemporary belts from Old Crow are couched in floral designs. Sometimes the baby's name will be included, centered between repeated motifs. One belt observed for sale in a shop in Whitehorse announced BABY in the middle.

In Fort McPherson couched baby belts have been made since

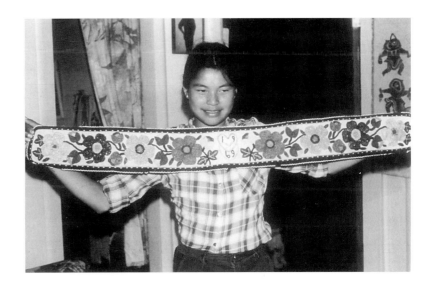

FIGURE 47 Granddaughter of Sarah Simon of Fort McPherson displaying a couched floral baby belt made there about 1969.

61

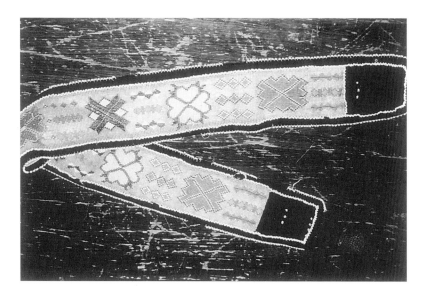

FIGURE 48 Woven baby belt made about 1934 by Charlotte Vhose of Aklavik.

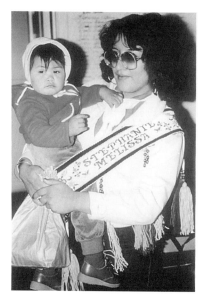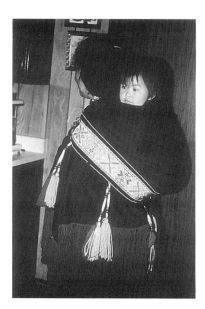

FIGURE 50 Left: Brenda Peterson of Fort McPherson carries her niece, Stephanie, using a baby belt of woven beads. Tying the belt over one shoulder and supporting the child on the hip is a recent development.

Right: The same baby carried in a shawl in the traditional way on the back of her grandmother, Florence Peterson, who noted that she would not go to sleep unless she was "packed." Shades of lavender dominate the design of this belt, made about 1981 by Susan Peterson. The fringes are strung with long hairpipe beads.

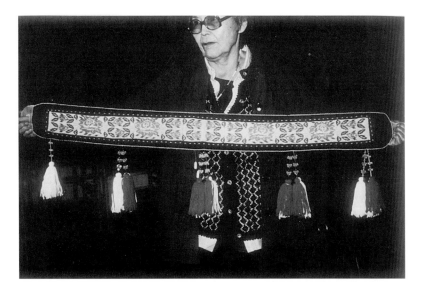

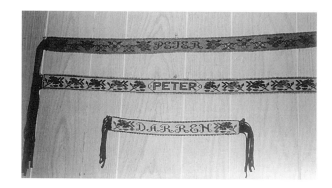

FIGURE 49 Eunice Carney displaying a woven baby strap made by Ellen Wilson about 1982, and offered for sale in the arts and crafts shop at Fort McPherson.

FIGURE 51 Several belts belonging to the children of one family, Fort McPherson, photographed in 1982.

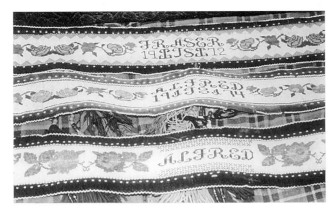

FIGURE 52 Belts woven by Olive Itsi, Fort McPherson, for her children.

the nineteenth century. Today, however, loom weaving is the preferred technique. Woven bead straps date at least to the mid 1930s at Fort McPherson. Today's belts tend to be narrower than earlier couched or woven ones and are conventionally mounted on a fabric backing and edged with a black velvet piping and a scalloped beaded border. It is common to place the name and sometimes the birthdate of the child at the center of the belt. Whether geometric or floral, many of the designs have been inspired by Ben Hunt's *American Indian Beadwork* and are of Plains or Woodlands origin, but women are not bothered by that "since they are Indian designs." Woven belts are occasionally also made at Old Crow.

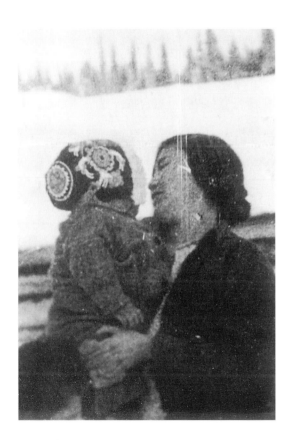

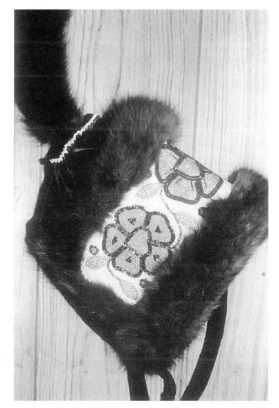

FIGURE 53 Left: Beaded baby bonnets have been made for many years but have never been so popular as baby straps. This unidentified photo of one probably dates to the 1930s. The large medallion-like flower was popular at that time. Booties with simple beaded designs have also been made for many years. Photo property of Dinji Zhuu Enjit Museum.

Right: Baby cap beaded in 1979 by Martha Benjamin, Old Crow.

63

In earlier times, keeping the family in serviceable footwear was one of the many responsibilities of the Athapaskan woman. Not only were utilitarian moccasins and boots for everyday wear necessary, but a woman who kept her family well was expected to make a new, specially decorated pair of moccasins or boots for each family member to wear during the festivities at New Year's. Today in Alaska, slippers and "fancy boots" are more apt to be made for the annual Old Time Fiddling Festival. As she worked on a pair of women's dance boots, Minnie Peter commented about why new footwear is now not so often worn at dances.

Long time ago they used to wear these—all these fancy boots and stuff. Nowdays they don't do that too often. The floor they don't keep so clean anymore—I mean things spilling all over the place ruin their boots, so they just quit doing that, little by little.

For many years the Kutchin wore a soft soled, pointed toe moccasin. It was cut with a T-shaped heel seam, a central toe seam, a small tongue, and an attached short cuff. Today they use a round toed moccasin constructed with a soft sole gathered onto a large tongue (moccasin upper). Short cuffs and fur finish around the ankle. (See Figs. 88–90 for a pattern and instructions.)

Elderly eyes lit up on seeing the pointed toe moccasin, the

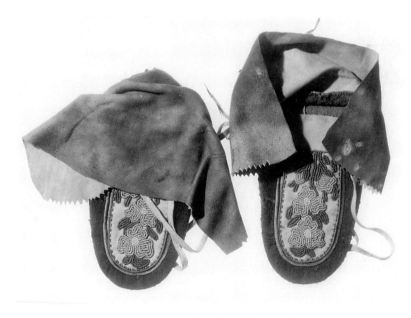

FIGURE 54 Pointed toe moccasins, Fort Yukon type. Hide, seed and metal beads, velvet. Typical pointed toe moccasins in cut, these are unusual in that they are beaded on tongue, body and upper. Hood Museum 42-15-7813.

FIGURE 55 Round toe moccasins, Kutchin. Hide, seed beads on felt. An insert of a narrow strip of hide is sandwiched between the tongue and the sole to provide a nice finish to the tongue and help strengthen the seam. Such an insert is common on jacket seams, also. National Museum of Man, Ottawa VI-I-68. Photograph courtesy National Museums of Canada.

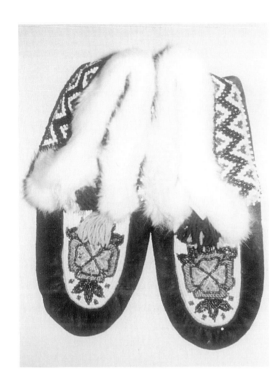

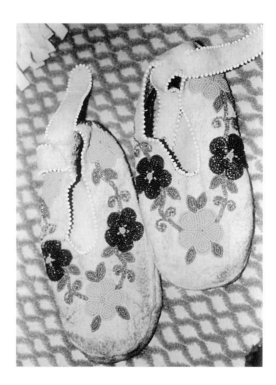

FIGURE 56 Left: Round toe moccasins, Old Crow, 1940s. Hide, beads, rabbit fur. The geometric work on the cuffs is netted in "Old Crow knitting."

Right: Slippers, made by Minnie Peter, Fort Yukon, 1982. These are similar to a pair made by Margaret John in the 1950s for a nurse in the community. The cut, with wide ties, is thought to have been suggested by a slipper illustrated in a magazine. (See also Dinji Zhuu Enjit Museum L-82-1.)

"sharp moccasin" once again. Several older women had made the type, but not for many years. When asked why the pointed moccasin was no longer worn, one woman suggested, "They don't like it, I guess. It doesn't take longer (to make.)" Another said that it is harder to put together because a quality job requires that no puckering show around the edge of the tongue. A very practical factor also pointed out is that pointed toe moccasins will not fit into moccasin rubbers, the shallow rubbers that fit over the shoe or moccasin to keep it dry. Today, those who prefer to wear moccasins all of the time often wear the rubbers much of the year when they are walking outside in order to protect the soles.

Sarah Simon, of Fort McPherson, chuckled as she remembered her husband's stepfather speaking about the introduction of the pointed moccasin from the Cree who came to the area with the Hudson's Bay Company.

[When] Hudson's Bay men they married Indian women around here, they [the Kutchin] first met those pointed shoes—on the tops went like this and were tied with string. They'd say, "What's wrong with your leg? Is your leg broken? It's tied together!" Then they'd see another one with the same shoes. They'd say, "What happened to your leg? Is it out of joint?"

And then he think up those half breed people wore loose shoes. And then they turned into Loucheux. That is what the old man say.

65

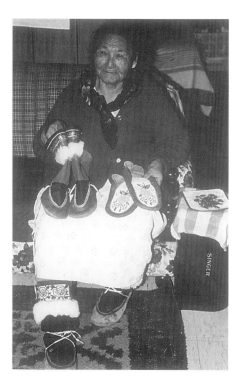

FIGURE 57 Sarah Abel, Old Crow, holding moccasins beaded by her daughter, Eliza, and the last pair of boots she made herself. The boots Sarah wears, with a large separate sole of hide, fabric tongue and upper combination, and beaded upper band are a type worn primarily by men for dress. Eunice Carney believes that this type was first made in Old Crow in the 1930s.

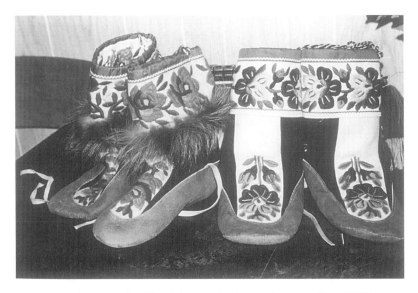

FIGURE 58 Boots embroidered in 1982 by Susan Peterson, Fort McPherson. Hide, duffle, wool yarn embroidery.

Early in the twentieth century in Fort Yukon, women sometimes made a version of the pointed toe moccasin with beading on the tongue but also over the body. Lily Pitka remembered her mother making a pair, and Sarah Abel of Old Crow had made some herself. On seeing a photograph of the heavily beaded type, Kutchin people admired the elaborate beading while some non-Kutchin women in the Great Slave Lake area felt that there was too much beading and disliked the dominant white of the stems. Museum specimens from around Great Slave Lake include far less white than do those from the western Kutchin and several other western Athapaskan groups.

Boots have been popular in Kutchin communities for many years, particularly for men. A simple utilitarian boot of canvas, worn in winter to keep snow out of the pant leg, is the model for the more elaborate decorated boot used on special occasions. Today at Fort McPherson the latter is often made with a hide sole attached to a narrow hide upper in a seam reaching all the way around the foot. The tall sides are constructed of duffle or felt, usually in panels of two colors, and are finished at the top with a decorated band.

Whereas solid beading is common on the upper bands on dance boots made in Old Crow, in Fort McPherson women now often construct the band from folded bias tape. Segments of colored tape spaced at intervals behind a strip of white tape are caught as

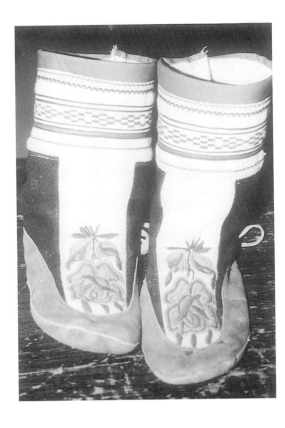

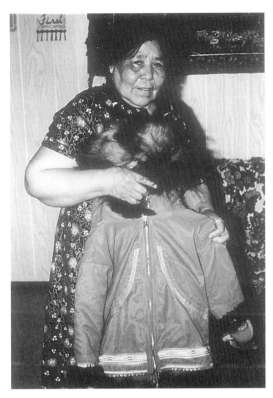

FIGURE 59 Left: Boots made in 1982 by Louise Snowshoe, Fort McPherson. Hide soles, uppers of duffle or felt embroidered with floss. The upper band ornament is produced using folded bias tape.

Right: Louise Showshoe, Fort McPherson, with a parka she made in 1982 using the applique bias tape technique for the hem band.

the strip is machine sewn down. The colored pieces are then folded over the white and caught in the stitching for the next strip overlapped below. A commercial operation located first in Aklavik and now at Inuvik uses this technique in the making of hem bands for parkas, as do women at Fort McPherson.

Fort Yukon has been famous for its jig moccasins and boots since the first decades of the century. Low cut women's slippers of hide with a solidly beaded tongue and cuff continue to be popular today. Women's boots were apparently more common in earlier years but some are still made. A few examples of tall women's boots from the turn of the century imitate European ladies boots and

are laced through eyelets up the front. The beading is directly on the hide, and runs across the foot and up the leg on either side of the lacing. More common in collections is a shorter woman's boot with a solidly beaded tongue and applied bands running up the front and along both a lower and an upper cuff. White rabbit is the traditional fur trimming for women's boots.

Since men's dance boots have no front lacing, the vertical beaded bands are placed on either side of the ankle if they are present at all. Such bands are generally wider than on the woman's boot. Beaver fur trim is traditional for men's boots, sometimes with wolverine strips hanging from the upper band.

67

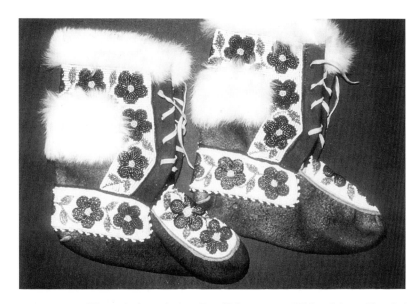

FIGURE 60 Woman's dance boots, Fort Yukon, 1950s. Hide, plain and beaded felt, beads, white rabbit fur. University of Alaska Museum 68.98.1380.

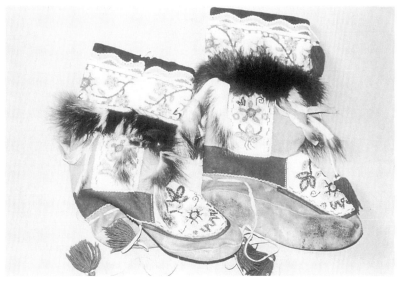

FIGURE 61 Man's dance boots, made in 1940 by Eliza Ben Kassi, of Old Crow, for her son Paul, a well-known Yukon dog musher. Hide, felt, fabric, beads, wolverine fur, yarn tassels.

MITTENS AND GLOVES

Short mittens and a knife case, both embroidered with quills or dentalia and/or beads accompany many of the old style Kutchin tunics in collections. The patterning on them usually matches or complements that on the tunic and moccasin trousers. Today embroidered knife cases are rare, but mittens and gloves continue to be important.

The mitten type now preferred by the Kutchin incorporates a large gauntlet separated from the hand portion by a fur band. Both the back of the hand and the guantlet are beaded. A longer mitten with no gauntlet and an inner liner of duffle added for warmth was also made in earlier times. The Kutchin mitten is ornamented on the back of the hand and gauntlet. Occasionally on turn-of-the-

century examples the outer part of the thumb will also have a bit of beaded design. Doris Ward commented that the women of the neighboring Tanana area cut the thumb of the mitten different than do the Kutchin. The inside thumb piece on the Tanana mitten is smaller than the outside and therefore reaches to just below the point of the thumb whereas the Kutchin seam will fall on the top of the thumb.

Lined mittens are very warm, but gloves are important for tasks where the fingers must move. There are fewer gloves than mittens in collections of turn-of-the-century Kutchin beadwork, but both are popular today. Because of the separated fingers there is less space for ornament on a glove than on a mitten and the shape available looks awkward. Women at Fort Yukon have developed a

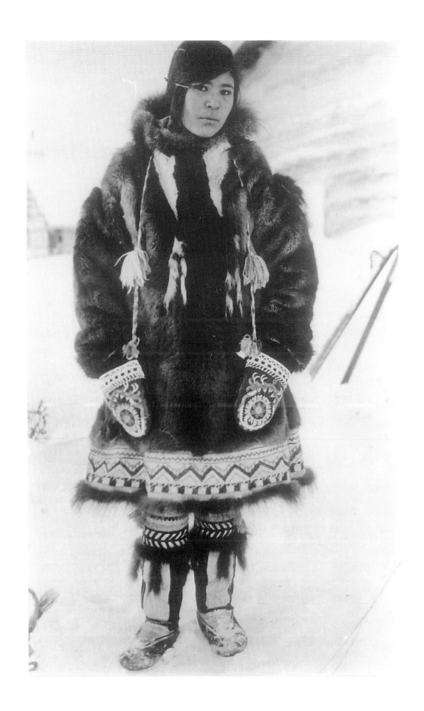

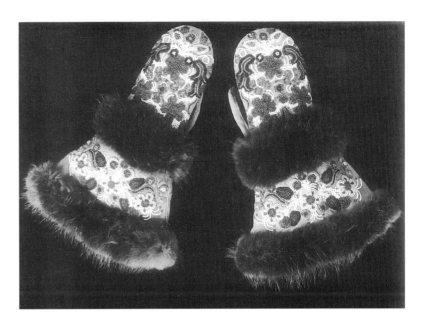

FIGURE 63 Man's mittens, Fort Yukon, early 20th century. Hide, seed and metal beads, fur. Exact symmetry on mittens is important in quality work. University of Alaska Museum, Fairbanks 68.5.1. Photograph courtesy University of Alaska Museum

FIGURE 62 Nellie Abel of Old Crow, ca. 1935 wearing a caribou skin parka. Her mitts are the short type without gauntlets, where ornament is concentrated on the hand and along a wide band at the wrist. The braided yarn string with tassels keeps the mittens from being dropped when the hands are slipped out for some purpose. The string is sometimes worn inside the sleeves of the parka. Photograph courtesy of Eunice Carney.

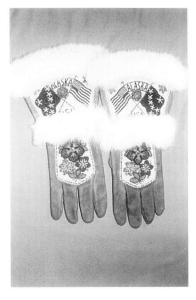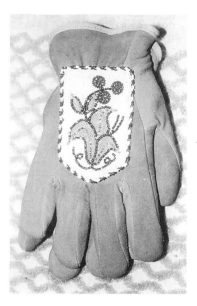

FIGURE 64 Left: Handmade gloves of Native tanned hide, with gauntlets and applied medallions. Made in 1935 by Mary Thompson of Fort Yukon. The American flag was a popular beadwork motif in earlier years. The V-shaped petal relief is still used in Fort Yukon. Hide, beaded felt, rabbit fur.

Right: Commercially made hide glove with attached hand medallion, medallion beaded by Minnie Peter, Fort Yukon, 1982. Hide, felt, beads. Attaching a beaded medallion to a commercially made glove allows for fancy gloves when hide and/or time is in short supply.

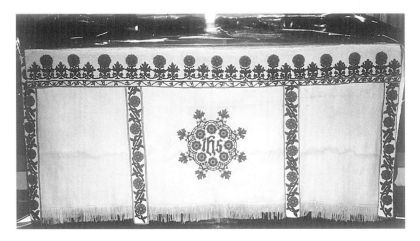

FIGURE 65 Altar cloth, St. Stephen's, Fort Yukon, beaded at the end of World War I as a thanks offering for peace. Blues, greens, red, and yellow dominate. The background of the floral portions is solidly beaded with white beads. Attached to the back is a list of beadworkers who participated on the project: Catherine Loola, Laura Jones, Belle Peter, Mary Johnson, Charlotte Paul, Martha Wallace, Jenny and Maria Colin. Fort Yukon has occasionally experienced severe flooding during Spring breakup. The hide shows stains from high water during the flood of 1949 when the church building washed away. After that the present church was built, relocated on higher ground.

solution by beading separate medallions on felt then attaching them to the backs of gloves. Since hides are now difficult to obtain, medallions are often applied to commercially made hide gloves such as those available in 1982 in Fort Yukon at Ray's Supermarket.

SPECIAL GIFTS FOR THE CHURCH

For many years the church has been an important spiritual and social focal point in Athapaskan communities. The Catholic Church (the Oblates and their sister order, the Grey Nuns) became well established among Canadian Athapaskans after the mid 19th century. In Alaska and the bordering Yukon Territory the Episcopal Church has been the most active. In all communities, having a permanent mission building has been important even though it might not have a resident minister, and by the 1890s many community churches had been constructed.

In the twentieth century, the women in most Kutchin communities have combined their efforts to bead at least one altar hanging for the community church. The women of Fort Yukon appear to have initiated the idea among the Alaskan Kutchin. St. Stephen's, in Fort Yukon, has three beaded altar hangings. The

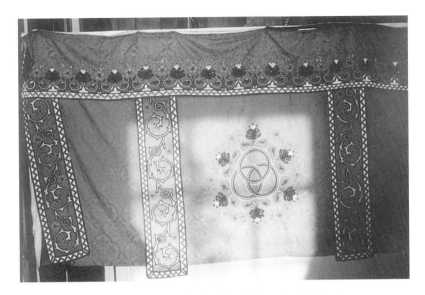

FIGURE 66 Altar cloth, St. Stephen's, Fort Yukon, beaded in the 1940s on a green-gold brocade. Stems are white outlined in blue, bells in gold and red, rosettes in pastel pink and blue, and stacked leaves in dark green and crystal. Points of leaves and petals are accented with a touch of a contrasting color.

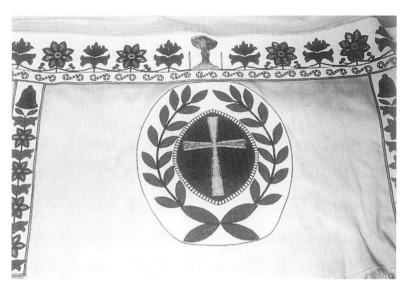

FIGURE 67 Altar cloth, St. Stephen's, Fort Yukon, made in 1964. The strips and central medallion are beaded on felt applied to a bleached hide background. Poinsettia-like rosettes in red alternate with leaf forms in two shades of green. The cross and chalice are gold, the bells black.

first, made at the end of World War I as a thanks offering for those who returned safely, is beaded directly on a ground of creamy white unsmoked, sunbleached moosehide. The floral patterning of alternated rosettes along serpentine stems on it and a matching lectern hanging is based on that of traditional Episcopal Church furnishings and was drawn by Mrs. Burke, the wife of the minister. The points of red at the tips of leaves in the central medallion are characteristic of other Fort Yukon beadwork at the time.

A second altar cloth was beaded for St. Stephen's in the 1940s, and a third in the 1960s. The second uses a green-gold brocaded fabric ground. The motifs are delicate, the serpentine stem line of the earlier cloth now becoming a spiral protectively enclosing a cluster of bell-like flowers. The third altar hanging returns to the

bleached hide backing but the beading itself is on white felt which has been attached to the hide. Motifs are bolder than on earlier cloths.

Arctic Village, Venetie, and Old Crow are among other communities known for their altar hangings. The women of Arctic Village have made two cloths, one in 1924 and a second in 1957. It was suggested that the new cloth made at Fort Yukon at the end of World War I probably inspired the women of Arctic Village to also make one. Both of the Arctic Village hangings are specifically symbolic.

The older cloth is of avocado green felt. The large star and six smaller stars on either side, centered horizontally along the upper edge, represent Christ and the twelve apostles. A large central

71

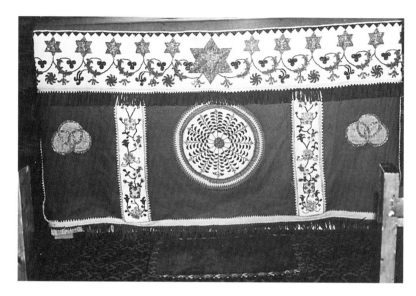

FIGURE 68 Altar cloth, Arctic Village, Alaska, made in 1924. Stars are a golden orange, stems red, leaves green, and floral forms dark blue, teal, silver and pink. Crystal and "satin" beads are used along with the more common opaque ones. Crenelated or fringed felt edging in red, green, orange and ivory echo the colors of the beads.

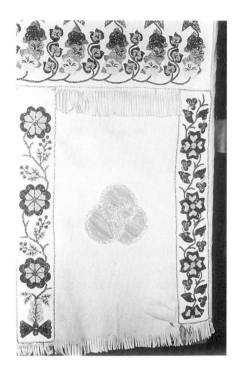

FIGURE 69 Altar cloth, Arctic Village, Alaska, made in 1957. Stars and vertical stems are gold; pansies are ivory, teal, and red next to small yellow blossoms framed by green leaves. Rosettes on the vertical strips are dark blue and crystal; berries are red.

circle below the band represents the world and the regularized pattern of leafed sprigs within it the multitude of nations. Flowers along the side bands and among the stars are small imaginative forms.

The later cloth from Arctic Village is of bleached hide, and retains much of the symbolism of the earlier one along with a more elaborate repeated floral patterning, primarily of pansies. Several different women designed motifs for this cloth. According to Josephine Peter, those who sewed on it were: Martha James, Nena Russell, Dorothy John, Mary Gilbert, Josephine Peter, Helen Tritt, Sarah Henry, Alice Peter, Ellen Tritt, Lily Tritt, Margaret Whiel and Florence Gilbert (see fig. 69).

A devout woman may sometimes make a special individual gift to the church, perhaps a beaded cover for the Bible used on the altar, or a stole for the priest to wear when holding services. The church in Fort McPherson has collection plates with delicate bead ornamentation. A beaded stole was made by Delores Sloan, now of Fairbanks, and presented to Pope John Paul II when he visited Fairbanks in May, 1984 (see Duncan 1984, p. 26). In Old Crow several women have made beaded pillows or wall hangings in honor of a deceased loved one and presented them to the church.

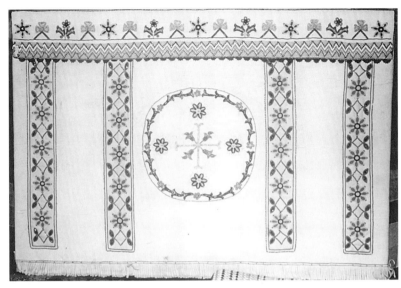

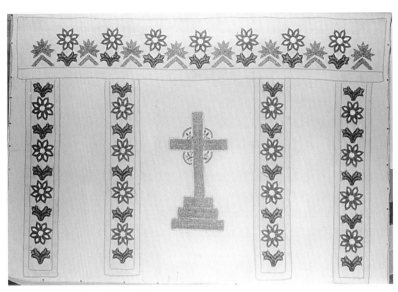

FIGURE 70 Altar cloth, Old Crow. The narrow band near the top was produced using the "Old Crow knitting" technique.

FIGURE 71 Altar cloth, Old Crow, made in 1981.

FIGURE 72 Left: Since the 1930s men in Old Crow have carried a special prayer bag to church. Although smaller than a man's sled bag, it is similar in shape and configuration with central and border beading on a flap that lies over the pouch. The bag was made ca. 1940 by Abbie Peter. The woven strap on this bag is unusual. Moose hide, caribou hide fringes, beads.

Right: Martha John Charlie, Old Crow, and the Bible bag she made for her husband about 1920 during a stay in the hospital at Fort Yukon. The beads came from Fort Yukon.

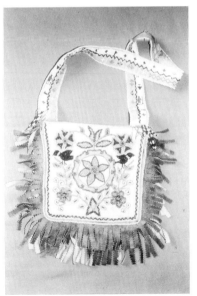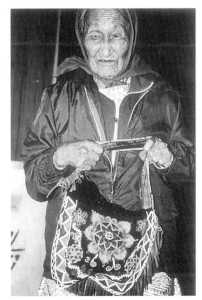

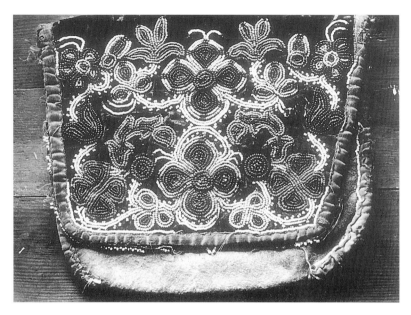

FIGURE 73 Pouch found in the basement of the church at Fort Yukon after the 1982 flood.

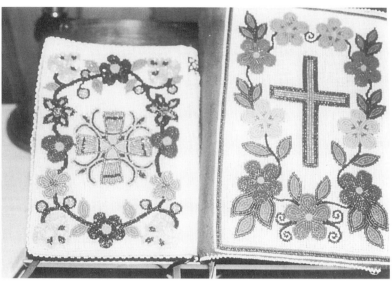

FIGURE 74 Bible covers presented to St. Stephen's Church in Fort Yukon. Left, probably by Mary Thompson; right, by Hannah Solomon.

FASHION AND FANCY

In Kutchin communities, just as elsewhere, fashion is important. A particular type of barrette or earring will be the rage one year only to be replaced the next by a new style. Personal items—beaded checkbook covers, glasses cases, change purses, cigarette cases, and lighter covers—are always fashionable. In recent years, barrettes, pendants, earrings and parka pulls have been popular both for personal use and for sale.

Early in the century, household items such as shelf valances, small cases to hold watches or scissors, and larger pockets to hang on the wall for holding letters, mementos or sewing materials were often beaded. Undecorated wall pockets to hold combs and brushes were common over the washstand, but a fancy one might hang in the living room. As life has changed, so have the household items beaded. Wall pockets are now seldom made and new items include coasters, lamp pads, picture frames, ash trays, and playing card covers. Although any of the above may be offered for sale in a curio shop, all are also made for use within the Kutchin household. Beaded pictures to frame and hang on the wall are a recent innovation. Delores Sloan, of Fort Yukon and Fairbanks, has made several of United States presidents.

The heavily beaded shelf valances that were popular in the Fort McPherson area early in the 20th century (Fig. 7 right) were unfamiliar to western Kutchin women. Alice Peter, of Arctic Village,

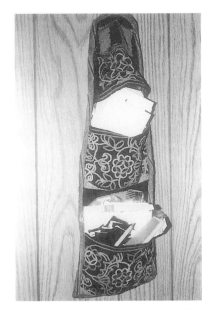

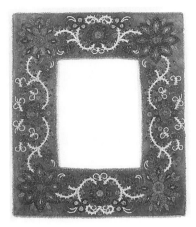

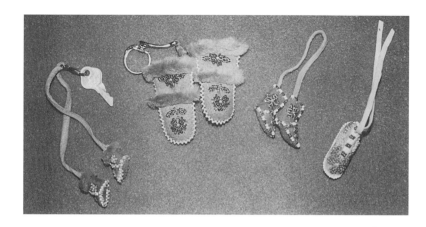

FIGURE 76 Key chains and parka pulls, Fort Yukon, 1980s.

FIGURE 75 Left: Wall pocket still in use in Old Crow. Narrow military braid *niltłyaa* outlines a floral design similar to beaded ones of the period. Petals with loops such as these are not done in beads. The pocket came originally from Arctic Village.

Right: One of a pair of picture frames, made by Jennie Roberts of Circle ca. 1928. The lacy stem work is typical of much western Kutchin work early in the century. Anchorage Historical and Fine Arts Museum 70.74.4.

commented: "They always travel around. They have no time to make. They only use tent!"

In recent years, special beadwork has also been produced for regional events such as the Arctic Winter and Summer Games and competitive dog racing, in which chosen individuals represent their communities. An entry in the Miss Indian America contest or other beauty pageants means one or more elaborately beaded garments will be needed. Since 1983 the Old Time Fiddling Festival in Fairbanks has become an important arena for the display of new work.

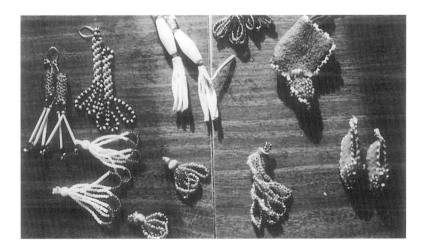

FIGURE 77 Earrings and parka zipper pulls by Doris Ward, Fort Yukon, 1982. Parka pulls are put on children's coats especially so that they can handle the zippers in very cold weather. A pair of tiny booties or moccasins might be used as earrings or separated and hung on a parka or a keychain. Some women enjoy making these detailed replicas of larger items while others have no patience with such tiny things.

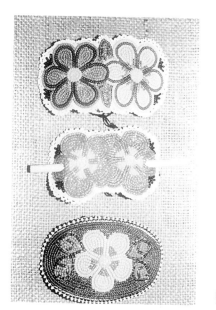 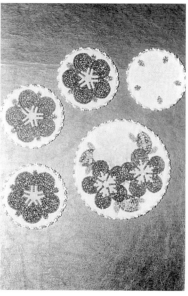

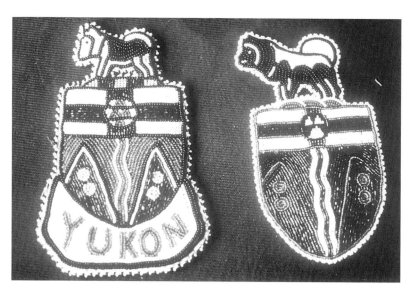

FIGURE 78 Left: Hair barrettes made by Margaret James, Arctic Village, 1982, for sale in a Fairbanks shop.

Right: Coasters beaded by Mary Thompson, Fort Yukon, 1979.

FIGURE 80 Beaded Yukon Territory insignias made to be worn on the parkas of competitors during dog racing. The one on the right was made by Alice Frost, Old Crow, in 1975.

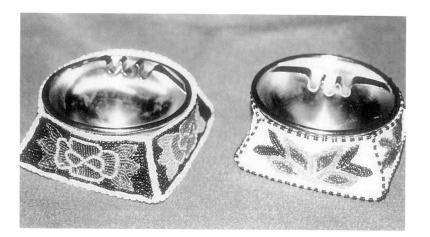

FIGURE 79 Ash trays, beaded in the 1950s by Sarah Herbert Henry, Fort Yukon.

CHAPTER VII ❋ *One Beadworker's Experience : Eunice Carney—Reminiscences*

MY BACKGROUND

I was born in a small place called Rampart House, Yukon Territory. It is located on the border between the Yukon Territory and Alaska. The people later moved to Old Crow, eighty miles farther north, because of wood shortage in Rampart House. I was sent to school at an early age. My Dad (who was born near Arctic Village) had had a hunting accident, and as a result passed away. So, to relieve mother of caring for four young children, Bishop Stringer, Anglican Bishop of the Yukon Territory, had me go to school 2,000 or so miles away from home in Carcross. It took two weeks to get there. I couldn't speak a word of English.

The students at the school at Carcross were from all over the Yukon Territory. Two Eskimo boys came one year from Herschel Island located on the shores of the Arctic Ocean. When it came time for them to leave school to go home from Carcross, they had to travel to Seattle, Washington and take a supply ship that went around the coast of Alaska to the Arctic Ocean and back to Herschel Island.

Going to an English speaking school 2000 or so miles away from home, an isolated village, when only six, must have been very hard on me. Years later on making a trip to Whitehorse, I met one of the students that was at the Chouttla Indian School before me. Chouttla means "Laughing Water" in the "Loucheaux" Old Crow language. I have always thought that it was strange that they would give it that name when it was located at Carcross, so near Tlingit country.

This student, Edward Henry, was happy to see me. He said that when I first arrived at the school all I did was cry. Thinking back about the time spent there I consider it a privilege to have gone to school. We all had our chores to do and rules were strict. One such rule was that the boys and girls were not to communicate in any shape or form. Years later I met one of the matrons, Lucy, and told her how unjust that rule was. She said "r-rules were r-rules."

Twice every Sunday we girls had to go in a group with the matron and walk two miles to church in town, once in the morning and again at night, summer and winter, in all kinds of weather.

Lucy and I were happy to find each other. She was living in Vancouver, B.C. and we had moved to Seattle, Washington, U.S.A. We went out to see her quite often and had many good visits, talking about school days. I wanted to know how old she was when

Eunice Carney was born in 1909 in the Yukon Territory. At age six, when her father died, she was sent to the Chouttla boarding school in Carcross. When she returned to Old Crow ten years later, the trip required traveling down the Yukon River to Fort Yukon in Alaska, then up the Porcupine River back into the Yukon Territory. The flu epidemic raging in Fort Yukon on her arrival in 1926 halted her trip and she stayed the year, helping in the hospital and mission, before her parents could come to get her. After time in Old Crow, she returned to Fort Yukon where she later married Bill Carney and raised a family. Eunice now lives part of the year in Seattle, Washington and part in Clear, Alaska with a daughter. Her friends in the north have a special way of addressing her. There her name is pronounced Eu-nice-e.

she finally left school to persue other interests. She said "26." Then I thought she was old, and when she said she married a few years later, I was speechless. She said she did not have any children of her own so she considered the girls under her care at school her children. She was a lovely person.

We had some happy times at school. Before Christmas we'd practice carols after school. The deaconess there was the organist. Then, before Easter, we'd practice again. We went camping in the summer for a week or so. Once we girls, with the school principal, got up bright and early and climbed this mountain—First of July Mountain it was called.

One night when I was ten years old in the wee hours the fire alarm went off. We jumped out of bed, got dressed, and went outdoors and were all accounted for. We were all scared and cold. The fire was put out and after we all went back to bed in the dormitory we all felt guilty. This was because prior to going to sleep the night before, and because the matron was at a meeting downstairs, we had had a free-for-all fun. We were all jumping on our beds with the white bedspreads with red trim around. One of the girls was the minister and the rest of us were the congregation; we were having church services. Remarks were made and we'd all laugh. What fun we had, but when the fire broke out, one of the older girls said it was because we had played church.

Besides going to school we learned how to sew and cook, etc. I remember we girls making beaded napkin rings, and beaded picture frames for the staff for Christmas. We did floral designs. Mother sent me some beads from Rampart House one year. It must have taken months for them to come. The silver metal beads were my prize possessions.

It was hard for me when I came home to my people. I couldn't talk their language any more and they in turn could not talk English. It was then that I decided to learn the Indian beadwork from my mother, Eliza Ben Kassi. She was very pleased with my decision and helped me all the way.

FIGURE 81 Eunice Carney (right) and longtime friend, Margaret John, Fort Yukon, 1982.

MY MOTHER AND OLD WAYS OF SEWING

Mother was a capable wife and mother, as all Indian wives were. She attended to all the needs of the family: parkas and footwear to make, Indian food to prepare when Dad and brother Paul were to go out hunting or trapping. She really spoiled me by making a fancy fur caribou calfskin parka, full length, with a fancy design around the bottom made out of diamond shapes with white sheepskin and caribou calfskin, all sewn down by hand (Fig. 82). It must have taken her hours just to do the design. It also had strips of wolverine skin dangling in back and front of the garment and as a ruff around the hood. She never once had me try it on or do anything to see if it fit. She handed me the finished parka and it just fit, and I didn't even know she was making it. Then there were the fur pants, mittens and boots. Nothing was good enough for

78

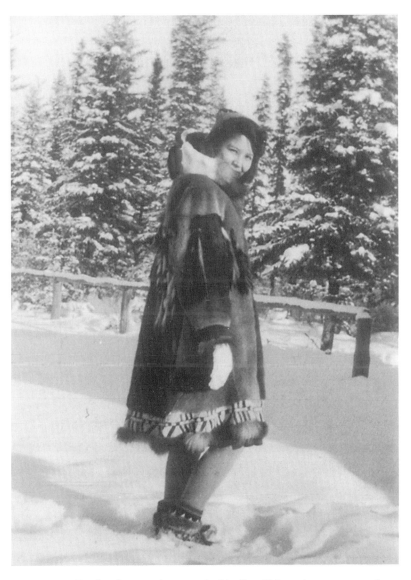

FIGURE 82 Eunice Carney, photographed in Fort Yukon about 1934 wearing a caribou skin parka made by her mother, Eliza Ben Kassi. Eunice was living in Fort Yukon when one day her brother Paul arrived with his dog team. He brought this parka, a surprise from her mother.

her daughter just home from school. I was the best dressed girl in the village. Bless her; she passed on a few years ago.

Pants with fur inside and feet attached and suspenders were something a person wore on the trail. The tanned skin was pure white with red Indian stone-dye on the seams and colorful beads strung around the ankles. In the spring when everything was wet, I remember mother greasing the foot part and especially the seams to make them waterproof.

All these garments were sewed with sinew. Sinew is made from the gristle that goes the whole length of the back of the moose or caribou. It is dried, then separated to make thread and rolled to a point for easy threading. Sinew is used slightly damp to sew hide together when making jackets, moccasins, parkas, etc.

The stitching used on hide and fur is overcast and in some cases, as in moccasin fronts or jacket seams, a narrow strip of hide is inserted between the two pieces of hide and the three layers are overcast together. The strip, which makes the seam stronger, is trimmed level with the garment.

The fringes for a caribou fur parka are made of wolverine skin cut in strips with the fur going downward. They are nicer if you cut them to include the yellow spot on the shoulder. One strip is sewed on in the middle of the back just below the seam where the hood lies. The rest are placed at intervals in a curve across the back and elsewhere down the front and back of the parka.

The fur pants mother made me were made of caribou hide. The fur was intact on one side and was worn inside. The other side was tanned white and worn outside. Never did I see her cut any of the garments out. She didn't have any pattern. I do know that the head part of the parka was made from the skin of the head of the animal.

Mother did all of her sewing sitting on the floor. I can still see her sitting there with her black hair parted in the middle and braided on each side. At 95 her hair was still black.

The caribou fur parkas are not made so much any more since a couple of tragedies occurred where a couple of men were mistaken

79

for a caribou. After making and wearing these parkas for generations this had to happen. This was in the Fort Yukon, Alaska–Old Crow, Yukon Territory region.

In the 1920s and even 1930s the women were still making their own blouses, dresses, skirts and slips called petticoats. The skirts were all cut a certain way, be they made of wool (beautiful Canadian plaids could be bought at Dan Cadzow's store in Rampart House in those days), silk or cotton. The price of the fabric must have been decided by the price of furs.

One of the women made herself a pure white caribou skin parka, full length, tanned on the outside and with the fur inside. She made the waist part big so she could carry a baby inside the parka on her back with a colorful Hudson's Bay belt tied around her waist to keep baby in place. The seams on the full length parka were dyed red outside, and on the back and front part were tassels made of strips of caribou hide strung with different color Hudson's Bay beads.

TANNING HIDES

Fort Yukon is the largest village on the Yukon River in Alaska, with about 800 people. The women all make beautiful moccasins with solid beaded fronts and mooseskin bottoms. Indian tanned mooseskin is hard to come by here now as fewer women are taking the trouble to do this hard, tedious job of cutting the hair off the mooseskin and scraping off the stubs. The raw hide weighs quite a lot. The women make their own tools for this. One kind of scraper is made out of a leg bone of the caribou from the knee to the ankle. It is cleaned inside and sharpened. Others are made of iron with wooden handles.

After the hair is removed, you turn the hide and scrape the fat and gristle off the other side. Then you soak it in water. You then build a sawhorse type frame against the building, get that heavy hide on it, balance it, and scrape until it is half dried on one side, turn it and repeat on the other side. A wife has other chores to do

around the house besides. The hide is put in a tub of water for a day or so. With a special made green piece of wood, they sometimes twist the hide around and around and let it sit thus to dry. This process of scraping and soaking goes on three or four times until the hide is soft.

Somewhere in the process they rub the moose brain on, all over the hide. Then comes the job of smoking it. Only after that is it nice and soft. A fire is built inside a dome-like enclosure made of willows. Two skins are sewed together to fit over the dome. This has to be watched closely to have it smoked evenly. Crumbly rotten wood from the woods is burnt to color the skin a nice color and give it that smoky smell, nice if you like the smell (and most people do), and terrible if you don't. All this takes 2–3 weeks or more. The little woman does this in her spare time. If she has it done for her, she gives half of the hide to the woman that did all the work.

A few of the stores carry commercially tanned skins and a few women do buy this to make moccasins, boot bottoms, jackets and vests, but they have proved not to be as good because in time the bottoms of moccasins and boots get slippery. The younger women have no interest in learning to tan skins, so it will be a lost art in a few years.

BEADWORK

In those days, in the late 1920s, bead-work was done in the old style way. We Athapascans yet do floral designs with stems and hair-stems done in white beads. The Indians called these mouse-tracks and the five petaled flowers they called dog paws. The center top of the flower petals and tip of leaves were of different color too. The beads were smaller, no. 14 or 16.

The contrast in bead colors were not so pronounced as they are now—Venetian beads, they were called. In those days the women all made home tanned mooseskin jackets for their husbands, with beaded yolk with fringe, beaded cuffs and beads down the front. Then they made these beautiful beaded bags with shoulder straps

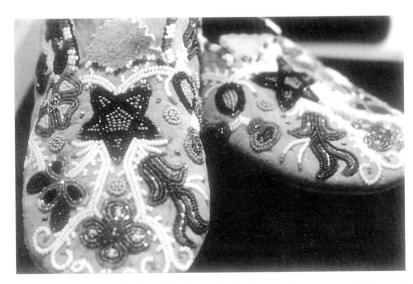

FIGURE 83 Slippers in the old style, made by Eunice Carney, 1983. Hide, seed and metal beads. Collection United States Department of the Interior, Indian Arts and Crafts Board.

which they called prayer bags for their husbands to carry their prayer books and Bible to church.

With Christmas (Little Day) and New Year (Big Day) drawing near, each mother was busy making beaded moccasins for each child, for her husband and herself for the holidays. What an array of beautiful footwear when they did their Indian dances. The custom in those days was that everyone in your family had to have a new pair of beaded moccasins or boots, whether you had twelve children or one. The dancing slippers had solid beaded fronts with a wide solid beaded strip around the ankle, with mooseskin bottoms and rabbit fur trimming on top. The beading was matched floral design.

Another custom was for the mother to make a beaded baby strap or baby carrier for each baby. It is four feet long and four inches wide, solidly beaded with floral design, with Hudson's Bay beads and yarn tassles. She was in style with a baby on her back wrapped in a black shawl with long fringe, and the beaded baby strap and the baby with a black velvet beaded bonnet.

During the 1960s–70s the women in Old Crow were making parkas ¾ length, out of Canadian material called stroud, in navy blue mostly, sold for $22.00 a yard in the store there. They used wolverine fur around the hood and cuffs and the bottom. The colorful design around the bottom is done with bias tape and rick-rack. On the sewing machine first you sew a yellow or any color strip of bias tape three or four inches from the bottom, then you start with the same color bias tape for a second row laid partly under the first but extending for an inch on top. Then sections of black or another color bias tape are cut about an inch in length and the ends are folded under. These are laid at intervals on the second long strip, also tucked under, and sewn down.

Now life is different in Old Crow, Yukon Territory. The women are not tanning the moose and caribou hides anymore, only a few. There is a modern school which goes to the ninth grade, then the children are sent to Whitehorse (the capital) to go to high school and on. There is a modern airport where jets bring mail and supplies three times a week.

OUR TRIP

First I want to say thank you to the Canadian Ethnology Service for making it possible for me to accompany Kate on this memorable trip. It was to places that were always interesting to me but that I never thought I would see. It was an experience I'll always remember. Kate was a wonderful person to work with and we did work hard. She had the stamina to do it all over again the very next day and do it cheerfully. We had fun and I thoroughly enjoyed it.

Places we went to were Whitehorse, Fairbanks, the Fort Yukon

area, Old Crow, Fort McPherson and the Yellowknife area. We had our first slide show in Whitehorse; the slides showed up very clear. Then Kate showed posters of beadwork she had enlarged. They were mostly beadwork from long ago. Then we had a question and answer period. Everyone was interested in the skin clothing the men and women wore in early days. I talked to Joanne, my relative, in Whitehorse; she was one of the good sewers in Old Crow. She seemed to think the beads and designs came to the country with the Hudson's Bay Company.

There is an arts and crafts shop in Whitehorse with all Indian-made articles. They used squirrels skin a lot for making jackets and boots and trimmings as squirrels are plentiful there. The lady in charge makes the parkas with the beautiful designs.

In Fairbanks we contacted the museum. The Institute of Alaska Native Arts Inc. scheduled a time for a reception and showing of slides and posters. We had a turn-out, over 100 people. Everyone was interested in the slides and posters. What impressed the women was the black velvet baby carrier just covered with bead-work all done with small beads. For some reason everywhere we went everyone recognized the tobacco pouch, so it seems that men used them all over the north. On them the beadwork is done on black velvet.

The Institute of Alaska Native Arts had a special show of bead-work from around the Fairbanks area at the Alaskaland Museum. It was most interesting. On display were a few solid beaded floral design baby straps that the mothers used to make for their new babies. They used to say a new baby strap for each baby—but not any more.

We interviewed a few women in Fairbanks. Sarah Malcolm is an elderly woman from Eagle, Alaska. Commenting on her younger days in Eagle, she said the teachers at the school told them to copy the flowers outdoors. I had always wondered where those forget-me-not designs on photo-album covers and bags came from.

Lily Pitka was another interesting person. She had dog saddles that she had made years ago. These were worn on the backs of dogs and tied underneath. Some were beaded and some embroidered with yarn; some even had bells. Dog saddles were used in the Yukon Territory and Northwest Territory and sometimes in eastern Alaska. Some of the beadwork designs are unbelievable, they are so beautiful.

I remember years ago in the mid 1920s at Fort Yukon, one winter Chief Christian came to town from Arctic Village with his whole family with three dog teams. As they neared town, you knew strangers were coming. Every dog had a beaded dog saddle with bells and colored yarn tassels. And Chief Christian himself looked like a chief should, with fancy fur caribou beaded boots with wolverine tassels around the top, tanned caribou fur parka with a fancy design around the bottom of diamond shapes done in sheepskin and with wolverine strips dangling on his back, tanned mooseskin beaded mittens with beaver fur trim, and a marten trapper's hat. A man was considered lucky if he had a wife able to make all these things. Those days are past and gone now.

Arctic Village is a small village out of Fort Yukon a ways. There the women still make the traditional garments and footwear for their families for the winter. The minister took Kate and me to the church to show us the beautiful beaded altar cloth made by the women there. We talked to Alice Peter, with an interpreter, Josephine Peter. She was a jolly person; there was lots of laughing.

Old Crow is the place where they make the beautiful beaded dancing slippers with solid beaded fronts and wide solid beaded sides with rabbit fur trim.

My observations are that the beads now used are larger and are made of glass. The seed beads are larger, too. It seems that the same beads are used all over, in Alaska, the Yukon Territory and the Northwest Territory. There is more beadwork done on an article in Alaska and the Yukon Territory and less in the Northwest Territory. All do the modern floral design; all are beautiful. The old style beadwork that was once done at the turn of the century

is seen only in the museums now. If there are some women doing it they are very few.

In Fort Rae, Kate and I went to see Vital Thomas; he seemed to be one of the few that had gone to school. Kate showed the beaded posters; the women were interested. They said they would like to see all those beautiful articles made again. This is where I realized that some of the words in their language sounded familiar. Around the Fort Yukon, Alaska and Old Crow and Fort McPherson area, for the word *nice* we say *niszi*; at Fort Rae they say *niszi-dia*.

I first met Eunice in 1977 when I was working on my art history Ph.D. thesis and Bill Holm, my major professor, said, "You should go visit Eunice Carney." I did, and that visit was the beginning of a long and cherished friendship and collaboration.

Eunice showed me her work and answered my questions. She told about her mother Eliza Ben Kassi in Old Crow, and agreed to take a tape recorder and record her. Unfortunately, the plug on the recorder did not fit the plugs in Old Crow, so, after she returned we decided to record Eunice instead. Over the years she patiently read what I wrote for this and other books and gave her observations. She gently suggested things I hadn't thought of and encouraged me when I became discouraged.

One day when I wondered aloud about what fun it would be to travel together to the communities in the north that she had talked about. She said, "Sure!" So, in summer 1982, funded by the National Museum of Canada, we set out on the seven-week research trip that resulted in this book. We were laden with equipment—slides, mounted photographs, slide projector, camera, tape recording, sleeping bags—and my ten-year-old son. Eunice was 73.

We interviewed in Whitehorse, deposited the son in Fairbanks, and headed north to Fort Yukon. Eunice knew most everyone there—and in Arctic Village, Old Crow, Inuvik, and Fort McPherson. We climbed in and out of bush planes, and we walked, and walked, and walked. Eunice was an excellent interviewer. Her graciousness, sense of humor, and enthusiasm for the project drew old and young, men as well as women, to look at our photos of turn-of-the-century Gwich'in and MacKenzie River beadwork and tell us what they remembered. I was pleased when I learned that in the north her name was pronounced E-*nice*-e.

We traveled up the MacKenzie to Great Slave Lake, then on to Fort Smith. At Fort Simpson Eunice treated me to a pork chop dinner (my favorite) to celebrate my birthday. We both thought I should learn to bead, and I can still hear her patiently saying, "Take it out and try again," as I struggled with forget-me-nots, the first flower a young girl learns to make. She stuck out her thumb when, on Great Slave Lake, we found ourselves needing to get back to Yellowknife, and was tickled that the woman who gave us a ride was named Madeline Chocolate. She compared Gwich'in and Dogrib words with elders at Fort Rae, helped interview an old Hudson's Bay dog runner at Fort Smith, and asked questions of retired Grey Nuns in Edmonton. I know how exhausted I was at the end of that trip, but she never complained. We worked very hard and had a lovely time, and finally a book with which we were both pleased.

We took other trips together—to the University of Iowa for her to demonstrate beadworking, and later to Yakima, Washington, and Warm Springs, Oregon, to interview beadworkers.

Kate Duncan, left, with Eunice Carney, 1986.

After beading became difficult for Eunice, she still reported to me what she saw and heard about the work of others, and talked of continuing when she could. The last time she showed her beadwork was in March 1993 at the Heard Museum in Phoenix, Arizona. Eunice died at the age of 84 on December 8, 1993, in Seattle, after several weeks of illness.

Eunice Carney left an important legacy as perhaps the only Gwich'in beader still working in the old style late in the twentieth century. She produced Percent for Art commissions in Alaska and Washington state, and her beadwork is in museum collections at the University of Alaska Fairbanks, Doyon, Ltd., the Department of the Interior in Washington, D.C., the Newark Museum in New Jersey, and the Fenimore House Museum in Cooperstown, New York.

Another legacy lies in her contributions to this book—the direction and information she brought to the fieldwork, the parts she wrote, and the beadwork patterns she graciously shared. This second edition of *A Special Gift* with its expanded color plates would have pleased her very much. After the book was first published she always let me know when someone in Fairbanks or Old Crow told her what it meant to him or her. She had hoped it would be printed again and would have joined me in gratitude to the University of Alaska Press.

—*Kate Duncan*
Arizona State University

85

Beadwork Designs From Eunice Carney's Design Tablet

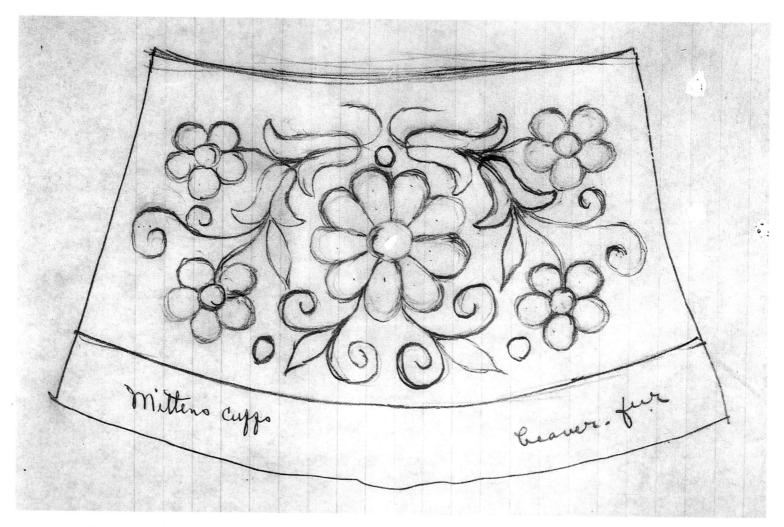

FIGURE 84 Mitten gauntlet design.

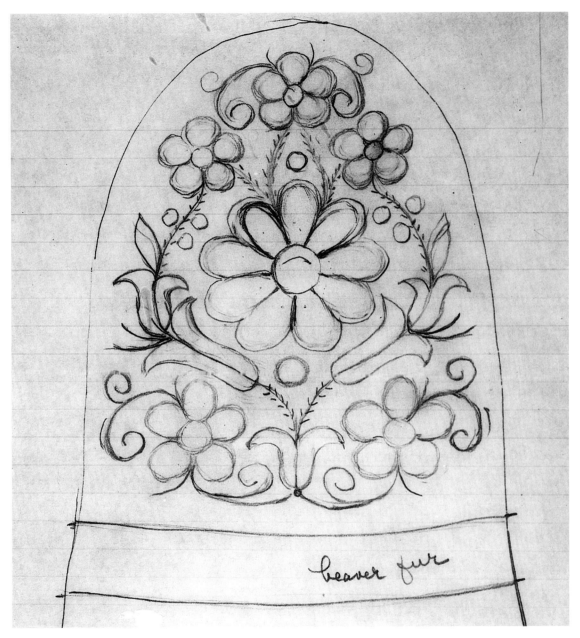

beaver fur

FIGURE 85 Mitten top design.

87

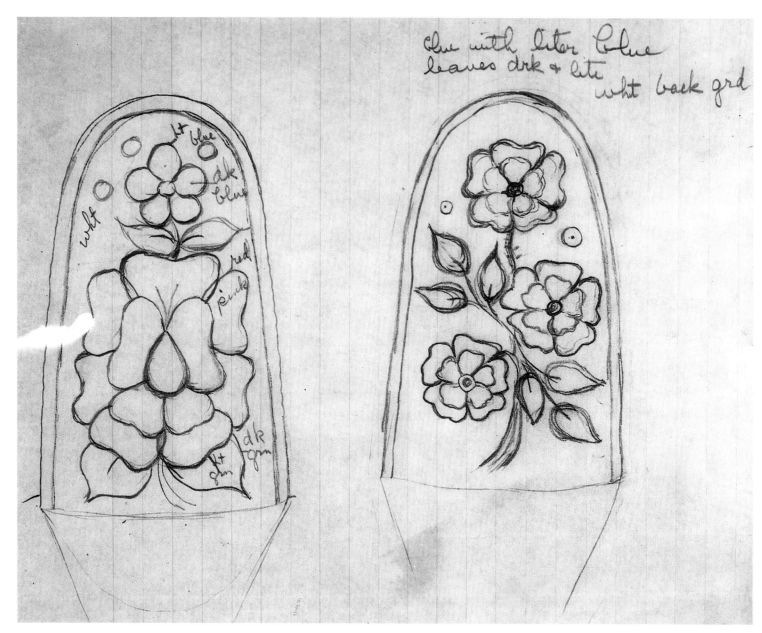

FIGURE 86 Moccasin-upper designs.

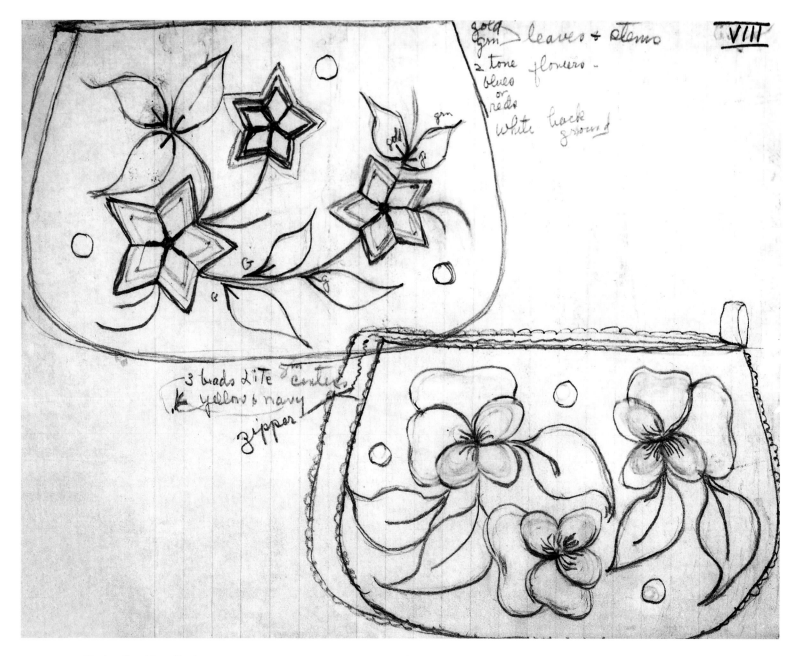

Handwritten annotations on the design:

VIII

gold
grn → leaves & stems
2 tone flowers -
blues
or
reds
white back ground

gold
& grn

3 beads LiTe 3 centers
K yellow & navy

zipper

FIGURE 87 Design for sides of a change purse.

89

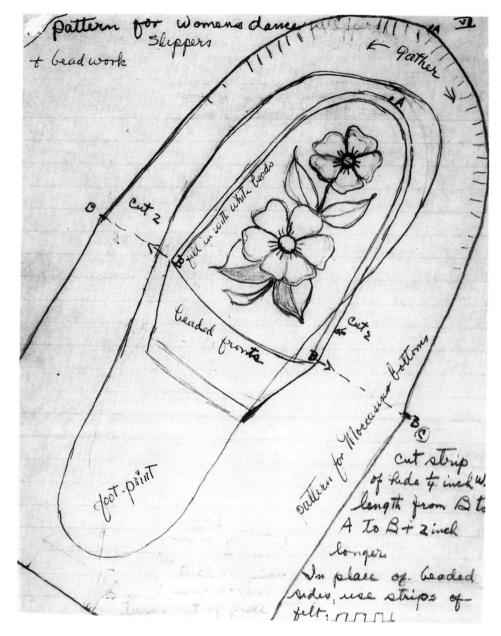

Pattern for Womens dance Slippers & bead work

Gather

fill in with white beads

beaded fronts

Cut 2

Cut 2

foot-print

Pattern for Moccasin bottoms

Cut strip of hide 4 inch W. length from B to A To B + 2 inch longer In place of beaded sides, use strips of felt.

90 FIGURE 88 Moccasin pattern with design for upper (see fig. 89 for cuffs pattern).

To Make a Pair of Moccasins

Cut out fronts (tongues) of moosehide or felt. Sew brown paper on back. Draw design and sew the design with beads on fronts. Fill in the empty spaces (background) with white beads leaving an edge all around from B to B.

Cut another set of fronts out of caribou hide and attach them to the beaded fronts using an overcast stitch. Cut out moccasin bottoms. Tack A on bottom to A on beaded front and tack B on bottom to B on beaded front. Be sure to fold bottoms and check to make sure the two Bs are even.

Cut a hide strip a quarter inch wide and long enough to reach around the moccasin front from B to B with one inch extra on each end. Working on the unsmoked side of the skin, gather the moccasin bottom onto the moccasin front where indicated, including the strip in the seam as you go along. To do this, sew on the wrong side with an overcast stitch catching in the fullness in a pucker between each stitch or so. Around the end of the toe the puckers are closer. Trim the excess strip around the edge of the beaded front to about ⅛ inch.

Dampen the area around the finished seam. With the handle of the scissors press the seam flat. Turn moccasin right side out and while it is still damp use the point of the scissors to smooth the puckers. Flatten out the entire front part of the moccasin and weigh it down with something heavy like a telephone book. Leave overnight.

Starting at the ankle, sew heel seam together on the inside to within one inch of the end (1). Use an overcast stitch. Cut in one inch as pictured (2). Push the flap inside, straighten (3). and sew

it across with an overcast stitch. Turn moccasin inside out and trim off flap.

Cut a strip of hide about 1½ to 2 inches wide and long enough to reach around the ankle. Seam it to the ankle on the right side using an overcast stitch. Flatten the seam so the strip stands up. Fit the beaded cuff around the raw edge and invisibly tack the top of the beadwork to the seam. (A single strip of felt or one of two contrasting colors can also be used as a cuff.)

Cut a piece of rabbit fur the same size as the hide strip and lay it, with the fur inside, on the outside of the hide strip. Sew the fur, felt and hide strip together at the top and sides using an overcast stitch. Turn the fur to the outside and tack along the bottom. For ties attach a narrow strip of hide on either side.

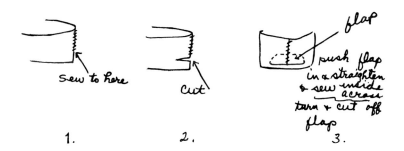

1. 2. 3.

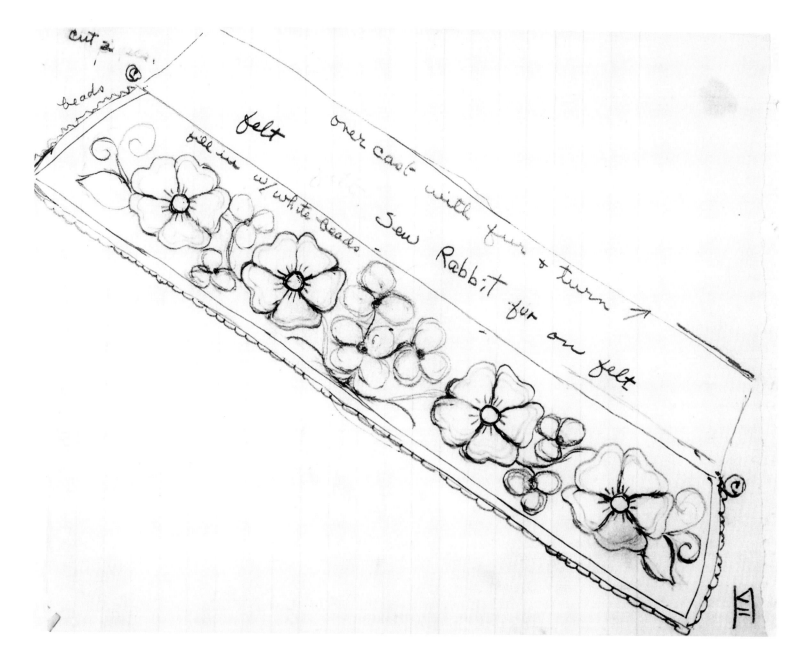

92 FIGURE 89 Moccasin cuff pattern and design.

Kutchin People Interviewed

NAME	COMMUNITY	APPROXIMATE AGE, 1982	NAME	COMMUNITY	APPROXIMATE AGE, 1982
Abel, Ellen*	Old Crow	70	Moses, Myra*	Old Crow	94
Abel, Sarah	Old Crow	80	Njootli, Joanne*	Old Crow, Whitehorse	70s
Benjamin, Martha	Old Crow	early 50s	Peter, Abbie*	Fort Yukon	73
Carney, Eunice*	Old Crow, Fort Yukon	73	Peter, Alice*	Arctic Village	60s
Firth, Mary*	Fort McPherson	70s	Peter, Josephine	Arctic Village	early 40s
Flitt, Martha	Fort Yukon	73	Peter, Julia	Fort Yukon	76
Fredson, Annie*	Old Crow	75	Peter, Louise	Fort Yukon	60s
James, Annie	Fort Yukon	65	Peter, Minnie*	Fort Yukon	55
James, Arthur*	Fort Yukon	65	Peter, Titus	Fort Yukon	65
James, Martha	Arctic Village	75	Pitka, Lily	Fort Yukon, Fairbanks	70
Johnson, Elliott	Fort Yukon	75	Simon, Sarah	Fort McPherson	75
Johnson, Lucy*	Fort Yukon	75	Snowshoe, Louise	Fort McPherson	60s
Kaye, Myra*	Old Crow	85	Solomon, Hannah	Fort Yukon, Fairbanks	73
Kendi, John*	Old Crow	70	Tizya, Moses	Old Crow	80
Knudson, Sarah	Fort Yukon	35	Tritt, Sr., Isaac*	Arctic Village	74
Malcolm, Sarah (Han)*	Eagle	77	Ward, Doris	Fort Yukon	58

* now deceased (1997)

References

Allen, Henry T.
1887 *Report of an Expedition to the Copper, Tanana and Koyukuk Rivers in the Territory of Alaska in the Year 1885.* Washington, D.C.: U.S. Congress, Senate External Documents.

Anderson, James
1858 *McKenzies River District Report.* Public Archives of Canada, MG 19.A 29.

Balikci, Asen
1963 *Vunta Kutchin Social Change.* Northern Coordination Research Centre, Department of Indian Affairs and Northern Development, Ottawa, 63(3).

Beaglehole, J. C., ed.
1967 *The Journal of Captain James Cook on his Voyages of Discovery, 1776–1780.* Cambridge: Cambridge University Press.

Beaver, C. M.
1955 *Fort Yukon Trader: Three Years in an Alaskan Wilderness.* New York: Exposition Press.

Bompas, William Carpenter
1888 *Diocese of the Mackenzie River.* London: Society for Promoting Christian Knowledge. (reissued 1922)

Bunzel, Ruth
1929 *The Pueblo Potter, a Study of Creative Imagination in Primitive Art.* Columbia University Contributions in Anthropology, no. 8. Reprint, New York: Dover Publications, 1972.

Cadzow, Donald A.
1925 Old Loucheux Clothing. *Indian Notes* 2: 292–95.

Cameron, Agnes Deans
1910 *The New North.* New York: Appleton.

Clark, Annette M.
1975 *Proceedings: Northern Athapaskan Conference.* Ottawa: Canadian Ethnology Service, Paper 27.

Collins, Henry B., et al.
1973 *The Far North: 2000 Years of Eskimo and Indian Art.* Washington, D.C.: National Gallery of Art.

Coues, Elliot, ed.
1897 *New Light on the Early History of the Greater Northwest: the Manuscript Journals of Alexander Henry, Fur Trader of the Northwest Company, and of David Thompson, Official Geographer and Explorer of the Same Company, 1799–1814.* 2 vols. Reprint, Minneapolis: Ross & Haines, 1965.

Dall, William H.
1870 *Alaska and its Resources.* Boston: Lee and Shepard.
n.d. Papers (field notebooks, diaries, letters). Smithsonian Archives, Record Unit 7073.

Dall, William H., G. M. Dawson, and W. Ogilvie
1898 *The Yukon Territory.* London: Downey.

Dawson, G. M.
1889 *Report on an Exploration in the Yukon District N.W.T. and Adjacent Northern Portion of British Columbia.* Annual Reports of the Canadian Geological Survey 3(1): 7–277.

Dickason, Olive P.
1972 *Indian Arts in Canada.* Ottawa: Department of Indian Affairs and Northern Development.

Duncan, Kate C.
1988 *Northern Athapaskan Art: a Beadwork Tradition.* Seattle: University of Washington Press.

1987 Yukon River Athapaskan Costume in the 1860s: Contributions of the Ethnographic Illustrations of William Dall. In *Faces, Voices and Dreams*. Edited by Peter L. Corey. Sitka, Alaska: Division of Alaska State Museums and the Friends of the Alaska State Museum.

1984 *Some Warmer Tone: Bead Embroidery of the Alaska Athabaskans.* Fairbanks: University of Alaska Museum.

1982 "Bead Embroidery of the Northern Athapaskans: Style, Design Evolution and Transfer." Ph.D. dissertation, University of Washington, Seattle.

1981 The Métis and Production of Embroidery in the Subarctic. *The Museum of the Fur Trade Quarterly* 17(3): 1–8.

1980 The Far Northern Plains Tradition: Eastern Athapaskan Applique. In *Native American Ribbonwork: a Rainbow Tradition*. Proceedings, 4th Annual Plains Indian Seminar. Cody, Wy.: Museum of the Plains Indian.

Fairbanks Native Association
1978 *Athabascan Beading.* Fairbanks, Ak.

Fitzhugh, William, and Aaron Crowell
1988 *Crossroads of Continents, Cultures of Siberia and Alaska.* Washington, D.C.: Smithsonian Institution.

Graburn, Nelson, Molly Lee, and Jean-Loup Rousselot
1995 *Catalog Raisonne of the Alaska Commercial Company.* Berkeley: University of California Press.

Hail, Barbara, and Kate Duncan
1989 *Out of the North, the Subarctic Collection of the Haffenreffer Museum of Anthropology.* Providence, R.I.: Haffenreffer Museum of Anthropology.

Hardisty, W. L.
1867 The Loucheux Indians. *Annual Report, Smithsonian Institution 1866*, 311–320.

Helm, June, ed.
1981 *The Subarctic.* Vol. 6, *Handbook of North American Indians*. Washington, D.C.: Smithsonian Institution.

Helm, June, et al.
1975 The Contact History of the Subarctic Athapaskans: An Overview. In *Proceedings: Northern Athapaskan Converence, 1971*. Ottawa: Canadian Ethnology Service, Paper 27.

Hodge, Frederich, ed.
1907 *Handbook of American Indians North of Mexico*, vol. 1. Bulletin, Bureau of American Ethnology, 30.
1910 *Handbook of American Indians North of Mexico*, vol. 2. Bulletin, Bureau of American Ethnology, 30.

Hudson's Bay Archives
Youkon Fort Post Journals. Hudson's Bay Archives MS. B24 Ou 1.

Hunt, W. Ben, and J. F. "Buck" Burshears
1971 *American Indian Beadwork.* New York: Collier Books.

Jenkins, Michael R.
1972 Glass Trade Beads in Alaska. *Alaska Journal* 2(3): 31–39.

Jenness, Diamond
1932 The Indians of Canada. Bulletin of the National Museum of Canada, 65, 1st edition.

Jones, Strachan
1866 The Kuchin Tribes. *Annual Report, Smithsonian Institution*, 320–27.

Krauss, Michael E.
1987 The Name Athabaskan. In *Faces Voices & Dreams*. Edited by Peter L. Corey. Sitka, Ak.: Division of Alaska State Museums and the Friends of the Alaska State Museum.

Krech III, Shepard
1976 The Eastern Kutchin and The Fur Trade, 1800–1860. *Ethnohistory* 28(3): 213–35.

Krieger, Herbert W.
1928 Tinne Indians of the Lower Yukon River Valley. *Explorations and Fieldwork of the Smithsonian Institution, 1927*, 125–132.

Leechman, Douglas
1954 The Vunta Kutchin. *Bulletin of the National Museum of Canada*, 130.
1951 The Old Crow Altar Cloth. *Canadian Geographical Journal* 43: 204–205.

Mackenzie, Alexander
1801 *Voyages from Montreal, on the River St. Laurence through the Continent of North America, to the Frozen and Pacific Oceans in the Years 1789 and 1793.* London.

McConnell, R. G.
 1891 Report on an Exploration in the Yukon and Mackenzie Basins,
 N.W.T. *Annual Reports of the Canadian Geological Survey for
 1888–1889*, n.s. 4: 10–163.

McKennan, Robert A.
 1965 The Chandalar Kutchin. *Arctic Institute of North America,
 Technical Paper* 17.

Michael, Henry N.
 1967 *Lieutenant Zagoskin's Travels in Russian America, 1842–44.*
 Toronto: University of Toronto Press.

Murray, Alexander H.
 1910 Journal of the Yukon, 1847–48. *Publications of the Canadian
 Archives* 4: 1–125.

National Museum of Man
 1974 *The Athapaskans: Strangers of the North.* Ottawa: National
 Museum of Man.

Nelson, E. W.
 1899 The Eskimos About Bering Strait. *Annual Report, Bureau of
 American Ethnology for the years 1896–1897*: 3–518.

O'Neale, Lila
 1932 *Yurok-Karok Basket Weavers.* Berkeley: University of California
 Press.

Osgood, Cornelius
 1975 "Athapaskan?" *Proceedings of the Northern Athapaskan Confer-
 ence, 1971*, Vol. I. National Museum of Man, Mercury Series,
 Ottawa.
 1936 Contributions to the Ethnology of the Kutchin. *Yale University
 Publications in Anthropology*, 14.
 1934 Kutchin Tribal Distribution and Synonymy. *American
 Anthropologist*, n.s. 36(2): 168–79.

Patterson, Nancy-Lou
 1973 *Canadian Native Art: Arts and Crafts of Canadian Indians and
 Eskimos.* Toronto: Collier-Macmillan Canada, Ltd.

Petitot, Emile, S. J.
 1876 "Dictionnaire de la langue Dènè-Dindjíe." United States National
 Museum, National Anthropological Archives, MS 169.

Public Archives of Canada
 Peels River Account. MG 19 D12.

Raymond, C. W.
 1900 Reconnaissance of the Yukon River, 1869. In *Compilation of
 Narratives of Explorations in Alaska*. U.S. Senate Committee on
 Military Affairs.
 1873 The Yukon River Region, Alaska. *Journal of the American
 Geographical Society* 3: 58–92.

Richardson, Sir John
 1852 *Arctic Searching Expedition: A Journal of a Boat Voyage Through
 Rupert's Land and the Arctic Sea.* 2 vols. New York: Harper &
 Bros.

Ross, Bernard R.
 1866 The Eastern Tinneh. *Annual Report, Smithsonian Institution*,
 304–11.
 1859 On the Indian Tribes of Mackenzie River District and the Arctic
 Coast. *Canadian Naturalist* 4: 190–97.

Russell, Frank
 1898 *Explorations in the Far North.* Iowa City: University of Iowa.

Russell, I. C.
 1895 A Journey Up the Yukon River. *Journal of the American
 Geographical Society* 27(2): 143–60.

Savoie, Donat
 1970 *The Amerindians of the Canadian North-West in the 19th Century,
 as Seen by Emile Petitot.* Vol. 2: The Loucheux. Ottawa:
 Department of Indian Affairs and Northern Development.

Schmitter, Ferdinand
 1910 Upper Yukon Native Customs and Folklore. *Smithsonian
 Miscellaneous Collections* 56(4): 1–30.

Schwatka, Frederick
 1900 A Reconnaissance of the Yukon Valley, 1883. In *Compilation of
 Narratives of Explorations of Alaska*. U.S. Senate Committee on
 Military Affairs.
 1885 *Along Alaska's Great River.* New York.

Sherwood, M. B.
 1965 *Explorations in Alaska, 1865–1900.* New Haven: Yale University
 Press. Reprint, Fairbanks: University of Alaska Press, 1992.

Siebert, Erna
1980 Northern Athapaskan Collections of the First Half of the Nineteenth Century. Trans. David Kraus. *Arctic Anthropology* 17(1): 49–76.

Slobodin, Richard
1966 *Metis of the Mackenzie District*. Ottawa: Canadian Research Centre for Anthropology, Saint Paul University.
1964 The Subarctic Metis as Products and Agents of Cultural Change. *Arctic Anthropology* 2: 50–55.

Stewart, E.
1913 *Down the Mackenzie and Up the Yukon in 1906*. London: John Lane.

Stuck, Hudson
1917 *Voyages on the Yukon and its Tributaries: A Narrative of Summer Travel in Interior Alaska*. New York: Scribner.
1916 *10,000 Miles With a Dogsled: A Narrative of Winter Travel in Interior Alaska*. New York: Scribner.

Thompson, Judy
1994 *From This Land: Two Hundred Years of Denes Clothing*. Hull: Canadian Museum of Civilization.

1987 No Little Variety of Ornament. In *The Spirit Sings: Artistic Tradition of Canada's First Peoples*. Calgary: Glenbow Alberta Institute.
1972 Preliminary Study of Traditional Kutchin Clothing in Museums. *Mercury Series, National Museum of Canada*, 1.

Time-Life Books
1995 *Hunters of the Northern Forest*. Alexandria, Va.: Time-Life Books.

VanStone, James W.
1981 Athapaskan Clothing and Related Objects in the Collections of the Field Museum of Natural History. *Fieldiana Anthropology*, n.s. 4.
1974 *Athapaskan Adaptations*. Chicago: Aldine.

Varjola, Pirjo
1990 *The Etholen Collection: the Ethnographic Alaskan Collection of Adolf Etholen and his Contemporaries in the National Museum of Finland*. Helsinki: National Board of Antiquities of Finland.

Whymper, Frederick
1869 *Travel and Adventure in the Territory of Alaska*. New York: Harper.

Wrangell, Ferdinand P. von
1970 The Inhabitants of the Northwest Coast of America. *Arctic Anthropology* 6: 5–20.

Index*

* Page numbers for figures and information
found in captions are in italics.

About the Authors

Kate Duncan, author of *Northern Athapaskan Art, a Beadwork Tradition*, is an associate professor of art history at Arizona State University. Eunice Carney, born in 1909 in Old Crow, Yukon Territory, lived in Alaska for most of her life; her beadwork is included in several museum collections.